# THE SILK ROAD AND BEYOND

## Travel, Trade, and Transformation

THE ART INSTITUTE OF CHICAGO

YALE UNIVERSITY PRESS, NEW HAVEN AND LONDON

# THE ART INSTITUTE OF CHICAGO

ISSN 0069-3235

ISBN 978-0-300-12428-6

Executive Director of Publications: Susan F. Rossen; Editor of *Museum Studies*: Gregory Nosan; Designer: Jeffrey D. Wonderland; Production: Sarah E. Guernsey and Carolyn Heidrich; Photo Editor: Joseph Mohan; Subscription and Circulation Manager: Bryan D. Miller.

This publication was typeset in Stempel Garamond; color separations were made by Professional Graphics, Rockford, Illinois. Printed by Meridian Printing, East Greenwich, Rhode Island.

Distributed by Yale University Press, New Haven and London
www.yalebooks.com

This publication is volume 33, number 1 of *Museum Studies*, which is published semiannually by the Art Institute of Chicago Publications Department, 111 South Michigan Avenue, Chicago, Illinois, 60603-6404.

For information on subscriptions and back issues, consult www.artic.edu/aic/books/msbooks or contact (312) 443-3786 or pubsmus@artic.edu.

Ongoing support for *Museum Studies* has been provided by a grant for scholarly catalogues and publications from the Andrew W. Mellon Foundation.

Front cover: *Seventeenth-Century Interior* (detail; p. 28, fig. 8).
Back cover, clockwise from top right: *Ewer* (detail; p. 73); *Bodhisattva* (detail; p. 34); *Panel* (detail; p. 63); *Women Engaged in the Sericulture Industry* (detail; p. 57).

# Contents

# Acknowledgments

Like its companion exhibition, *The Silk Road and Beyond: Travel, Trade, and Transformation*—and the Silk Road Chicago project itself (see p. 5)—this issue of *Museum Studies* was a highly collaborative endeavor, and many people have contributed immeasurably to its success.

Both the exhibition and publication were a perfect opportunity to explore the charge that James Cuno gave to the Art Institute's curators when he assumed the museum's directorship in fall 2004: to think about and interpret our permanent collections in new and different ways. As it happened, the theme of the Silk Road was supremely suited to his idea, which was to explore unexpected connections between artworks rather than separating them, as we usually do, by culture, geography, and historical period.

The idea for this issue of *Museum Studies*, first suggested by Robert Eskridge in the Art Institute's Department of Museum Education, was initially pursued by Mellon Curatorial Fellow Christina M. Nielsen and Gregory Nosan, Editor of *Museum Studies*, who met with many of the museum's curators to discuss the project and the objects it might include. With photographs in hand, they consulted with Director of Publications Robert V. Sharp and me to clarify our sense of how to proceed. When we first sat down together as a group, I could not have imagined how much our conversations would help shape not only the publication but also the exhibition, which in many ways echoes it. I am grateful to these three colleagues for their warm goodwill, hard work, and willingness to think creatively about how to explore a topic as expansive as this one.

But no book, however well conceived, comes into being without an author. This one involved a team of more than twenty, whose combined skill and thoughtfulness was indispensable. Three of the principal contributors, James Cuno, Yo-Yo Ma, and Milo C. Beach, supported the project from the first, generously sharing their time, expertise, and curiosity, as did Elizabeth ten Grotenhuis of the Silk Road Project. The same is also true of the Art Institute's curatorial staff, who drew our attention to a fascinating selection of objects and wrote about them with elegance. My thanks go to Kathleen Bickford Berzock and Richard Townsend in the Department of African and Amerindian Art; Sarah E. Kelly, Ellen E. Roberts, and Brandon K. Ruud in American Art; Janice Katz, Elinor Pearlstein, Tanya Treptow, and Jay Xu in Asian and Ancient Art; Lisa Dorin in Contemporary Art; Ghenete Zelleke in European Decorative Arts; Stephanie D'Alessandro, Larry J. Feinberg, Christina M. Nielsen, and Martha Wolff in Medieval through Modern European Painting and Sculpture; Elizabeth Siegel in Photography; and Lucia Tantardini Lloyd (along with ex-intern Shalini Le Gall and former MacArthur Fellow Ray Hernández-Durán) in Prints and Drawings. Christa C. Mayer Thurman kindly shared her knowledge of objects in the collection of the Department of Textiles.

While Greg Nosan expertly refined the text from start to finish, he received valuable assistance along the way from Cristin Canterbury Bagnall, Mary Greuel, Susan F. Rossen, and Elizabeth Stepina. Jeffrey Wonderland is responsible for the publication's stunning design, which was realized by the skilled production team of Sarah Guernsey, Carolyn Heidrich, and Joseph Mohan in the Publications Department. Thanks also go to Bob Hashimoto, Susan Huang, and Robert Lifson in the Imaging Department. We are indebted, too, to Mary Swab and the staff of Mapping Specialists, Madison, Wisconsin, who created the splendid map on pp. 6–7; the skilled team at Professional Graphics, Rockford, Illinois, who made the color separations; and the experts at Meridian Printing, East Greenwich, Rhode Island.

I am deeply grateful to all of you for the many and generous ways you have shared your time and expertise. I also extend my heartfelt thanks to Mary Sue Glosser, Associate Director, Performance Programs, and my colleague-in-arms during this incredible journey of discovery.

KAREN MANCHESTER

*Elizabeth McIlvaine Curator of Ancient Art*

# Introduction

This issue of *Museum Studies* is an important component of the Art Institute of Chicago's contribution to Silk Road Chicago, as it provides a written complement to an extraordinarily complex collection of exhibitions and programs, each of which has asked, in its own way, the question at the heart of this endeavor: "What happens when strangers meet?" In these pages, you will find many answers to this query. Milo C. Beach, in his introductory essay, begins with the historical Silk Road, suggesting how encounters between cultures can inspire a fascinating, although not always easy, mix of understanding and imagination. James Cuno, the Art Institute's director and president, and Yo-Yo Ma, the acclaimed cellist whose world travels inspired him to found the Silk Road Project, talk about the power of art and music, and of Silk Road Chicago and their hopes for what it might achieve. The Art Institute's curatorial staff, in their entries on over forty works from every corner of the museum's collection, offer us a new sense of how art objects can illuminate over two millennia of aesthetic interchange.

In the summer of 2004, after an initial discussion over lunch with Beach, Cuno and Ma discussed the idea of a Chicago residency as they met backstage after the latter's performance at London's Royal Albert Hall. That conversation continued and broadened during a year of planning, growing into what has become a citywide collaboration of unprecedented range and ambition. Beginning in June 2006 and lasting for over one year, Silk Road Chicago, whose partners also include the Silk Road Project, the Chicago Symphony Orchestra, and the City of Chicago Department of Cultural Affairs, has featured hundreds of programs and performances, many developed in concert with other community organizations.

The Art Institute has been proud to serve as one of the crossroads for this project—the only venue in the city in which Silk Road Chicago has been experienced every day. This publication's companion exhibition, *Beyond the Silk Road: Travel, Trade, and Transformation*, is the largest exhibition and program cycle ever mounted by the Art Institute, and it has encompassed a vast array of endeavors. Several orientation galleries have been entirely devoted to the theme, featuring a changing array of objects from the historical Silk Road as well as modern and contemporary artworks that embody the idea of cultural transmission. Starting there, visitors have been able to travel the Silk Road throughout the museum: over 150 objects in several dozen galleries have been highlighted and specially interpreted. In addition, individual curatorial departments have mounted many other, focused installations exploring topics ranging from Tang China and the Silk Road to the work of contemporary Kyrgyz artists Gulnara Kasmalieva and Muratbek Djumaliev. The most extensive of these is *Perpetual Glory: Medieval Islamic Ceramics from the Harvey B. Plotnick Collection*, opening in March 2007.

Throughout the year, artists, musicians, and scholars have been in residence at the museum, culminating in a two-week-long stay in April 2007 by the Silk Road Ensemble. These residencies have featured gallery demonstrations, discussions, lectures, and performances by such artists as Fayeq Oweis, Krithika Rajagopalan, Gendun Saykal, Yang Hui Tang, and Silk Road Ensemble members Yang Wei and Betti Xiang, many of which have explored the intersection of visual and musical culture across space and time. Our museum educators have also planned a stimulating, equally ambitious series of offerings, including symposia featuring esteemed scholars of African, European, and Islamic art; lectures by such noted figures as Kwame Antony Appiah, Oleg Grabar, and the team of Ann Ping Chin and Jonathan Spence; reading courses; daily gallery walks; and family programs.

As Beach suggests, the Silk Road is capable of inspiring many different tales. Silk Road Chicago, wide-ranging and multifaceted as it is, is no different. For those of us at the Art Institute, working on this project and getting to know all the remarkable people associated with it has been at once incredibly stimulating and deeply satisfying. It is my hope that this publication—both the beautiful objects within it and the stories we tell about them—will be a source of inspiration and pleasure for you, too.

KAREN MANCHESTER

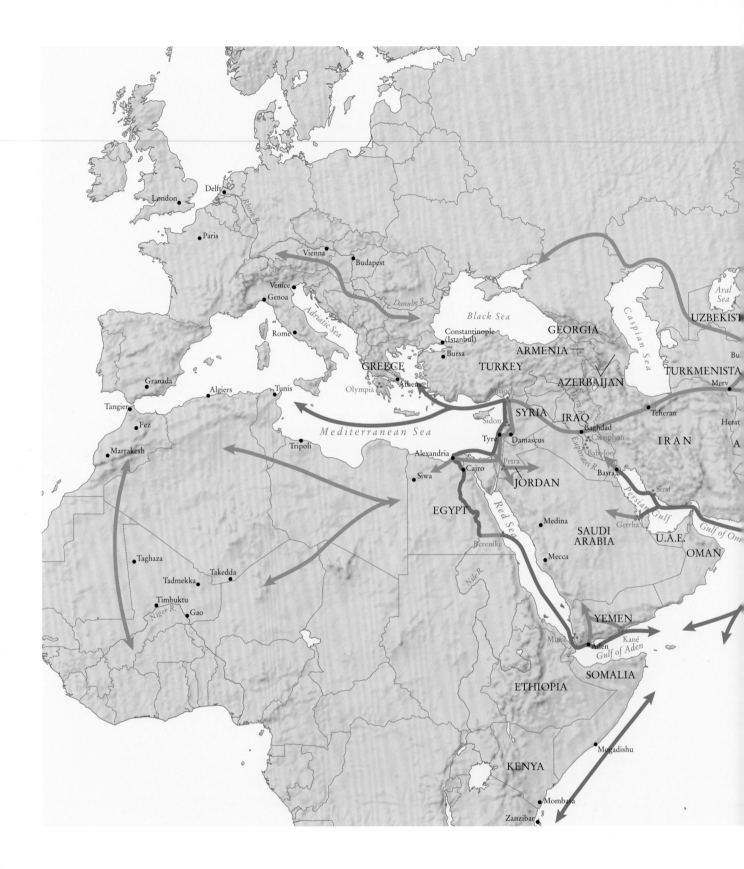

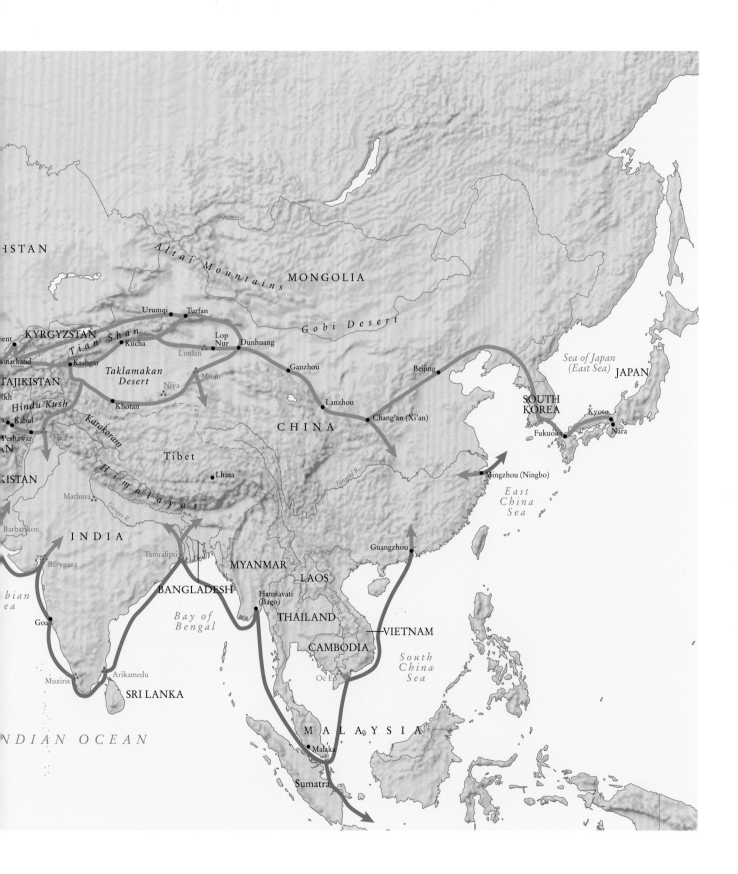

# Directions of Land and Sea Trade
## c. 200 B.C.–A.D. 1500

● Cities
∴ Archeaological sites

7

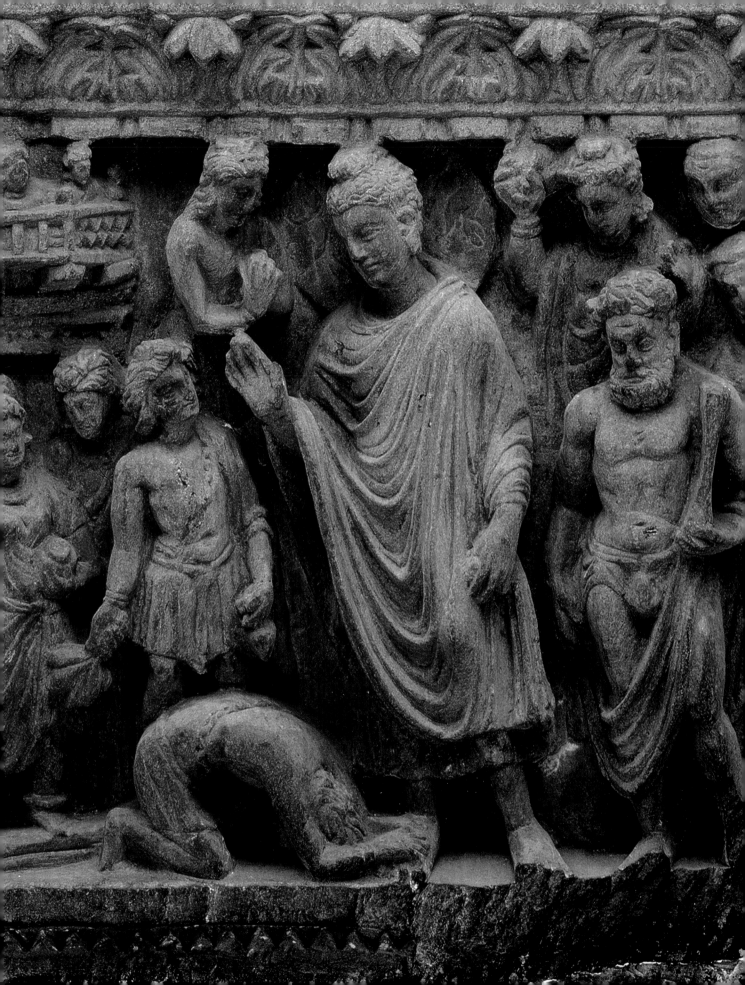

# The Ear Commands the Story:
# Exploration and Imagination on the Silk Road

MILO C. BEACH

Kublai asks Marco, "When you return to the West, will you repeat to your people the same tales you tell me?"

"I speak and speak," Marco says, "but the listener retains only the words he is expecting. The description of the world to which you lend a benevolent ear is one thing; the description that will go the rounds of the groups of stevedores and gondoliers on the street outside my house the day of my return is another; and yet another, that which I might dictate late in life, if I were taken prisoner by Genoese pirates and put in irons in the same cell with a writer of adventure stories. It is not the voice that commands the story: it is the ear."

Italo Calvino, *Invisible Cities*

IF WE BELIEVE Marco Polo's fictional words to Khubilai Khan, it was difficult even in the fourteenth century to convey a disinterested idea of the lands through which he traveled—which included a large section of what we today call the Silk Road. And if his reports gave reliable information about the preparation in India of the pigment indigo, for example, they also repeated rumors about Prester John, a Christian king of immense wealth and power who was thought to rule an unknown land deep within Asia. Such stories must have made the continent seem less forbidding to European Christians, yet Prester John was a complete fiction. In this case, it was Polo's own ears that were to blame.

The term *Silk Road* refers to a loose network of east–west trails that connect China with the Mediterranean. Separating to skirt mountains, occasional lakes, and deserts such as the Taklamakan, itself a 1,500-mile expanse of constantly moving sands, the routes cover a total

OPPOSITE: Detail of *Relief with Scenes from the Buddha's Life* (fig. 2).

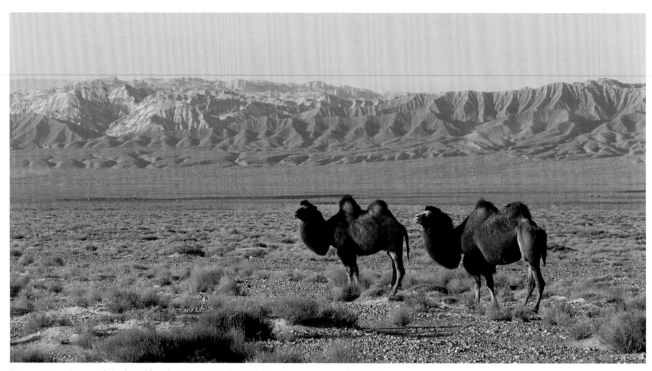

FIGURE 1. Bactrian camels in the Taklamakan Desert, Xinjiang Uighur Autonomous Region, China.

distance of about five thousand miles across some of the world's harshest landscapes (see fig. 1). While certainly evocative, the name is nonetheless misleading as well as relatively modern. Coined by the German explorer Baron Ferdinand von Richtofen in the nineteenth century, it refers to Europe's interest in silk, which—like the more revolutionary export, paper—first came west from China. The Chinese themselves used these routes historically to import horses from the Ferghana Valley (located in present-day Uzbekistan, Kyrgyzstan, and Tajikistan), camels from Bactria (in Afghanistan and Tajikistan), Persian luxury metalwork and textiles, and jade from Khotan, among other things, and might have named them accordingly had they felt such a need.

The Silk Road regions were populated by continually shifting tribal groups with distinctive ethnic and political affiliations; by peoples with wide-ranging religious beliefs and cultural practices; and by merchants, missionaries, and adventurers who traveled over some portion—but seldom the entirety—of the routes.[1] Well-preserved remains of mummified Caucasians, possibly four thousand years old, have recently been found among settlements in what is now the Xinjiang Uighur Autonomous Region in China's westernmost reaches. While we know little about why

these people journeyed so far east from their homelands, wherever those were, further evidence indicates that the routes had by then already been actively traveled for as many as sixty thousand years.[2] For our purposes, however, it is from the second century B.C. to the empire of the Mongols in the fourteenth century that the Silk Road proper is most interesting. During this period and before, the meeting of travelers and settled residents provoked particularly intense and vitally creative cultural exchanges.

For example, it was along the western extension of what later became the Silk Road that the Persian emperor Xerxes had moved to invade Athens in the fifth century B.C.; in the same area, Alexander the Great retaliated a century and a half later by marching from Macedonia to capture Persepolis, the Persian capital. He then continued to India in an astonishing attempt at world conquest, establishing along his route a series of colonies that brought Mediterranean and Asian peoples and cultures together (although at first under Hellenistic dominance). Silk, transported from China by nomadic groups, first made its way to Europe during the second century B.C.[3]

As the result of Alexander's campaign, and in an example of exactly the sort of cultural borrowing and adaptation we see so often along the Silk Road, an almost completely

fictionalized version of the emperor came to occupy a place in Persian art and literature. In his great *Shahnama* (Book of Kings), written about the year 1000, the poet Firdausi constructed a history of Persian kingship in the pre-Islamic period from events already absorbed into folk legend. Here, in the single most important and influential Persian literary text, Alexander became Sikandar (or Iskandar); he appears with Persian features in the Art Institute's fifteenth-century illustration of an episode from the *Shahnama* in which Firdausi, himself writing from a remove of 1,300 years,

recalls Alexander's defeat of the Persian king Darius (see p. 35). By the time Firdausi had transformed his oral sources, Alexander had become historically unrecognizable.

The *Shahnama* describes battle after battle, pitting Persians against Arab and Turkic tribes, among others. This should come as no surprise, since warfare and conquest were basic incentives for much early Silk Road travel. About 138 B.C., two centuries after Alexander's military exploits, the Han dynasty Chinese emperor Wudi sent the first known Chinese envoy to "western" lands. Zhang Qian's mission was to form an alliance with the tribal Yuezhi, then gathered in Bactria. The emperor hoped (in vain, as it turned out) to persuade the Yuezhi to help him defeat a rival group, the Xiongnu. And just as Alexander's troops had sent home tales of the people and places they encountered, Zhang Qian returned to China with information on the rich and varied places along his route—all of which sparked imaginations even further.

In the mid-first century, the Yuezhi moved into northern India, where, known as Kushans, they supported Buddhism, consolidating their power by forming a rich imagery for its practitioners. Since they brought with them no artistic heritage of their own, they adopted local styles. In the region of Gandhara, where Pakistan and Afghanistan meet, these consisted of a variant of visual traditions introduced initially through Alexander's colonizing activities but greatly expanded by trading contacts with Rome. What resulted, among other things, were figures characterized by a naturalistic musculature that was draped in Mediterranean clothing styles alien to South Asia (see fig. 2). In other words, the aesthetic vocabulary of an indigenous Indian religion was created by an intruding group from Central Asia, who in turn adapted the artistic practices of a colonial power from the West. This kind of exchange happened continually along the Silk Road and its tributary routes.

From about the first century, monks and merchants carried Buddhism north

FIGURE 2. *Relief with Scenes from the Buddha's Life*, 2nd/3rd century. Gandhara (present-day Pakistan). Gray schist; 60 x 37.1 x 7.3 cm (23 ⅝ x 14 ⅝ x 2 ⅞ in.). James W. and Marilynn Alsdorf Collection, 180.1997.

from India, spreading it east along the well-established Silk Road trails. Eventually images in Gandharan style were taken along as models and didactic tools, and they, too, were copied and adapted along the way. Increasing prosperity allowed Buddhists to establish resting places for travelers at strategic intervals, and the architecture and ornamentation of these structures drew from the varying communities they served. Indian, Chinese, and West Asian designs, therefore, freely intermingled with those local to Central Asia. Retreats such as the Mogao Grottoes (see fig. 3) offer material evidence of the creative ways in which ancient peoples combined visual styles and motifs in order to appeal to what we today might term "wider audiences," and they rank among the most fascinating artistic sites anywhere in Asia. Natural conditions proved severely damaging, however; virtually all of them were eventually lost, buried under the constant movement of the surrounding sands.[4]

The growth of traffic across Eurasia led to greater mutual awareness among distant peoples and cultures, increasing demands for unusual, exotic goods and helping to establish cosmopolitanism as a criterion of wealth and personal importance both in Europe and in Asia. During the Tang dynasty (618–907), riches flowed to China not only along the Silk Road but also through maritime trade, beginning by the first century.[5] Servants and entertainers from Central Asia, the Eastern Mediterranean, and Southeast Asia joined the merchants and missionaries—and the Bactrian camels—that moved through the bazaars. These visitors were captured in sculptures such as the Tang camel and the curly-headed, distinctly non-Chinese youth (figs. 4–5), which were among goods placed within tombs; such objects clearly expressed both China's fascination with other cultures and peoples, and the magnitude of its wealth, since many of them were made of gold and silver.

So great was China's openness to the world beyond its borders and its interest in the differences among cultural groupings that the Tang court maintained resident orchestras from Korea and Southeast Asia as well Bukhara, Kashgar, Kucha, Samarkand, and Turfan—each a Silk Road oasis city with distinctive local musical traditions.[6] This led to cross-cultural exchanges in music as profound as those in the visual arts. Textiles, easily transported, also went to China. Sometimes these showed Central Asian adaptations of European motifs that then fed the creativity of Chinese artisans; such is the case with a rare Tang silk in the Art

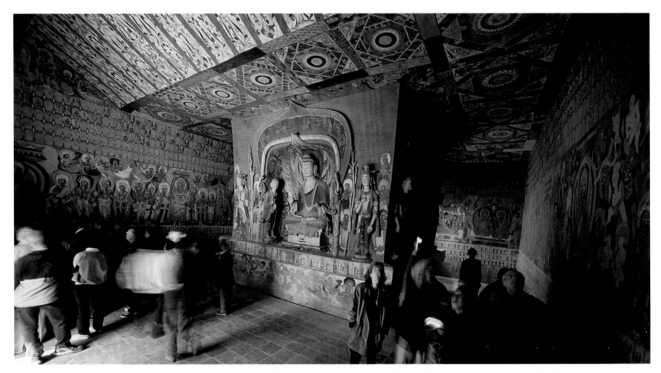

FIGURE 3. Mogao Grottoes, near Dunhuang in Xinjiang Province, China, are considered one of the finest and best-preserved examples of Buddhist art in the world. Now a major tourist attraction, they were excavated and painted by monks and travelers on the Silk Road.

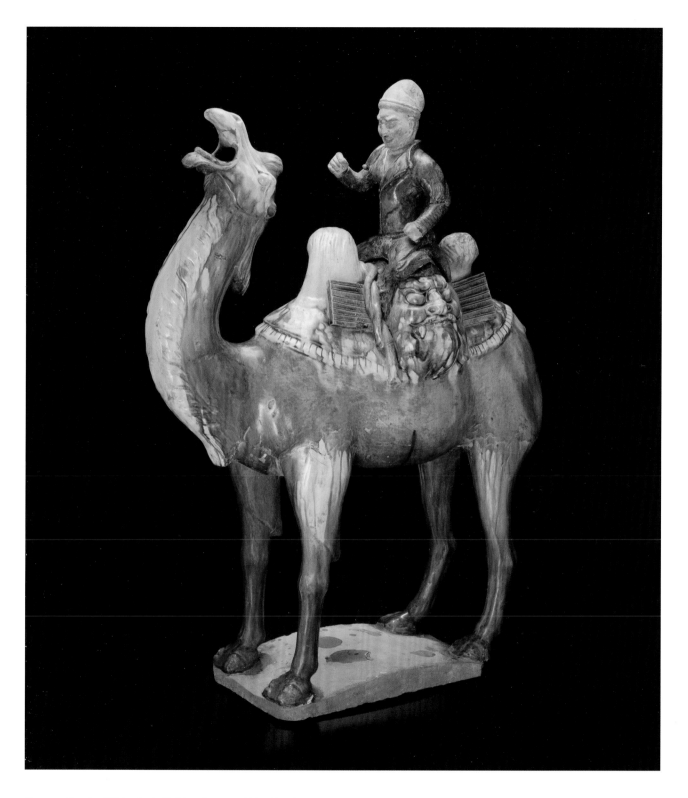

FIGURE 4. *Camel and Rider*, first half of the 8th century. China, Tang dynasty (618–907). Earthenware with three-color (*sancai*) lead glazes; 86.3 x 66 x 25.5 cm (34 x 26 x 10 in.). Gift of Bertha Palmer Thorne, 1969.788a–b.

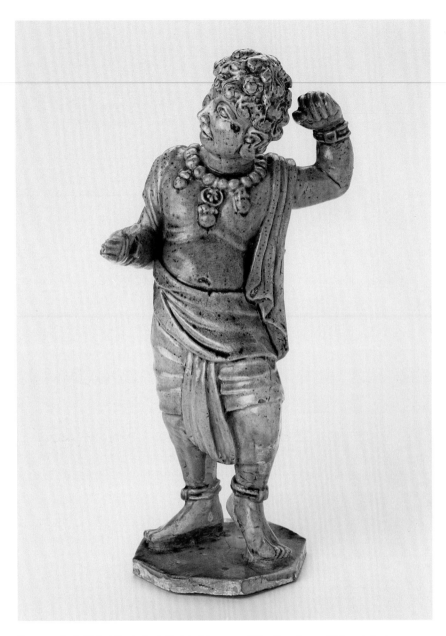

FIGURE 5. *Curly-Haired Youth*, first half of the 8th century. China, Tang dynasty (618–907). Earthenware with green lead glaze; 26.7 x 14.7 x 10 cm (10 ½ x 5 ¾ x 3 ¹⁵/₁₆ in.). Gift of Mrs. Arthur Wood, 1974.526.

Institute (fig. 6), with its Greek, split-palmette motif. Ceramic copies of Persian and Central Asian metalwork forms became popular in China and were frequently decorated with such West Asian motifs as the mounted archer shooting backward from his saddle (see fig. 7); this was the so-called Parthian shot, named for a startlingly effective tactic initiated by warriors of Persia's Parthian dynasty (c. 250 B.C.–A.D. 226).

Also in the seventh century, between 629 and 645, the Buddhist pilgrim and scholar Xuanzang traveled ten thousand miles to India through Western China, Central Asia, and present-day Afghanistan and Pakistan in search of knowledge and the original texts of Buddhism, since he was convinced that Buddhist texts had become corrupted by the translations and interpretations that followed their arrival in his native country. His reports of his adventures—

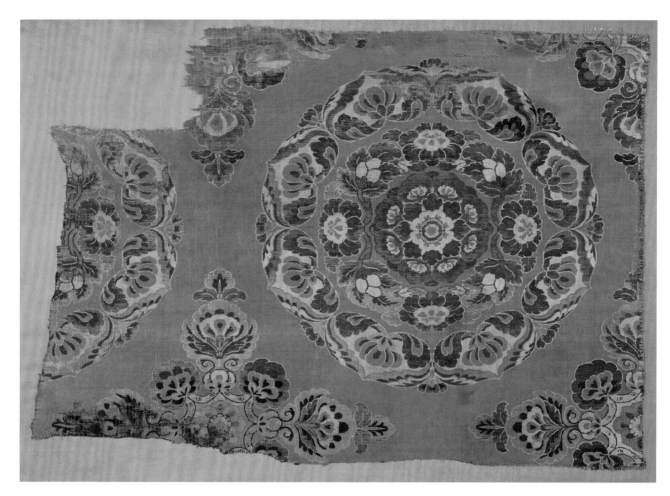

FIGURE 6. *Floral Medallions and Bouquets*, late 8th/early 9th century. China, Tang dynasty (618–907). Large fragment of silk, weft float faced twill weave of complementary wefts and inner warps; 61.6 x 90.2 cm (24 ¼ x 35 ½ in.). Robert Allerton Endowment, 1998.3.

in a perfect example of Polo's claim that "the ear commands the story"—generated folk tales that were finally set down in the late sixteenth century as *Journey to the West*, better known through the title given to a later English translation: *Monkey*.[7] Full of imaginary encounters with demons and magicians, this has become one of the most popular and enduring folk tales in all of Asia.

As we have seen, trade, missionary activity, and the diplomatic and military actions associated with rivalries and changing power balances—all were defining incentives for early Silk Road travelers. This was still the case hundreds of years later, for it was indeed the promise of profit that spurred Polo to undertake his extensive journeys in the late fourteenth century. He was seventeen when he left on his twenty-eight-year exploration of the lands between his home in Venice and China. Established as a Byzantine

town in the fifth century, Venice had initiated mercantile relations with the Islamic world by the eighth century and had long been an important source in Europe for spices and other goods from Central Asia and India. Through these contacts, the city had become immensely wealthy, its art and architecture saturated with West Asian motifs and sensibilities.[8] One example is a twelfth-century silk panel (fig. 8) that incorporates paired animals—in this case falcons—in a manner seen in both textiles from Persia's Sasanian Empire (226–650) and the Central Asian Buddhist wall paintings that they inspired.

Polo was not the only important later traveler. Ibn Battuta was twenty-one in 1325, when he left his home in Tangier to spend almost three decades exploring the extent of the Muslim world, a sojourn that also took him to Mongol China.[9] Throughout this entire route, he met fellow

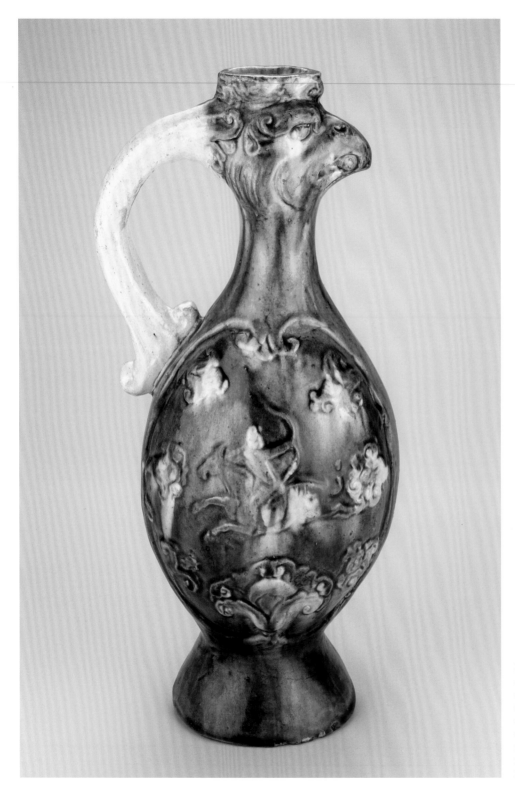

FIGURE 7. *Phoenix-Headed Ewer*, first half of the 8th century. China, Tang dynasty (618–907). Earthenware with molded decoration and three-color (*sancai*) lead glazes; 32.2 x 13 x 14.5 cm (12 $^{11}/_{16}$ x 5 $^{1}/_{8}$ x 5 $^{11}/_{16}$ in.). Gift of Pauline Palmer Wood, 1970.1076.

Muslims, so extensive was the range of Islam. (The religion had spread rapidly throughout Asia from the seventh century, and it still dominates many of the historical Silk Road lands today.) "During my stay in China," he wrote at one point, "whenever I saw any Muslims I always felt as though I were meeting my own family and close kinsmen."[10] The accounts of Polo, Ibn Battuta, and others not only made distant lands seem accessible but also established sheer adventurism as a new attraction for readers. Their words also inspired copycat (and largely fictional) accounts, of which that of John Mandeville (who claimed to have begun his travels in 1322) is the most famous, with its description of people with ears so large they used them as blankets to keep warm at night.[11] Because so much of what Polo and others described accurately already seemed so odd, the line between fact and fantasy was impossible for many to recognize. Nonetheless, all such narratives gave readers, for the first time, an immediate sense of the sweep and variety of peoples and places linking Europe to lands across Asia. As a result, Asia—however fancifully it was imagined—came to be as real to, and as constantly present in, the European imagination as the imported goods that had long been available in the markets. Such accounts also helped inspire the search for sea routes to Asia, which eventually caused the decline and virtual abandonment of the land trails.

However, the ever more frequent encounters between Europe and Asia that the Silk Road helped to establish did not diminish the inventive ability of people everywhere to fill gaps in—and answer concerns generated by—their knowledge. The fierce Ottoman Turkish armies that moved from Central Asia into Byzantine territories, conquering Constantinople in 1453 and threatening Vienna in 1683, for example, terrified Europeans into believing unimaginable atrocities, while tales of harems and *hamams* (baths) provoked intensely erotic fantasies. *Interior: Sultana Taking Coffee in the Harem* (fig. 9), by the Venetian artist Francesco Guardi, indicates the degree to which things Turkish were fashionable in eighteenth-century Europe, perhaps neutralizing the threat by moving it from battlefield to drawing room. In the 1730s, even Johann Sebastian Bach wrote a comic cantata on the dangers of drinking coffee, then a recent import to Europe brought by Turks from Yemen.[12]

FIGURE 8. *Fragment*, 12th century. Italy. Silk and gilt animal substrate wrapped linen, warp-float faced twill weave with supplementary patterning; 56.7 x 18.7 cm (22 ¼ x 7 ³/₈ in.). Purchased from the Field Museum of Natural History, 1907.900.

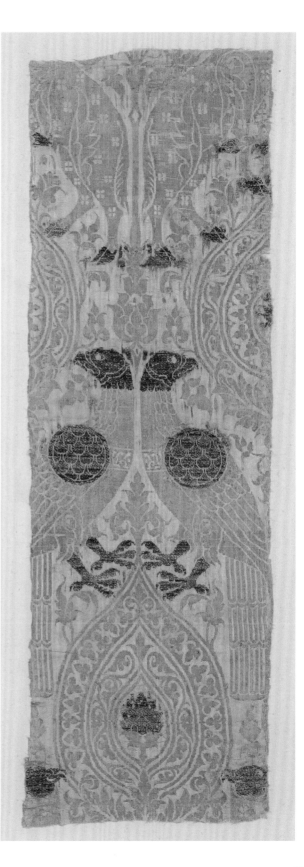

The familiar mix of attraction, repulsion, and identification with the "exotic other" was equally present almost a century later, when the British poet George, Lord Byron joined insurgents seeking the independence of Greece from the Ottoman Empire. Eugène Delacroix's *Combat of the Giaour and Hassan* (fig. 10), now in the Art Institute, brings romantic passion to a scene from *The Giaour* (1813), the first of Byron's *Oriental Tales*—the conflict of a Christian with a Turk over a woman fleeing the Turk's harem. The "Orient," by then often imagined as an undifferentiated entity, became a repository for the wildest flights of imagination by European romantics like Byron and was frequently represented as something uncivilized, threatening, needing to be subdued.[13] As such, it provided a perfect opportunity to proclaim one's own cultural superiority.

Given the important, although certainly not exclusive, roles that ignorance and imagination have played in coming to terms with unfamiliar parts of the world, and the misunderstandings that have sometimes ensued, how should we (whoever and wherever we are) proceed ourselves to be fair to the kinds of cultural encounters that the historical Silk Road has defined for us, and which are constant and even more wide ranging in today's world, where films, concerts, restaurants, and often our next-door neighbors so frequently introduce us to new cultural traditions? Amartya Sen, the Nobel Prize–winning economist, has recently written about the late Bengali Indian filmmaker Satyajit Ray, a particularly perceptive observer of our world. He isolates three elements that Ray kept constantly in mind, and that would serve us well also:

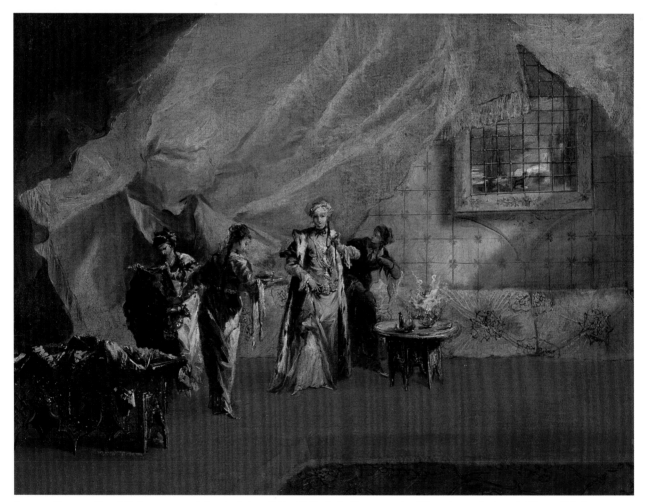

FIGURE 9. Francesco Guardi (Italian, 1712–1793). *Interior: Sultana Taking Coffee in the Harem*, 1742/43. Oil on canvas; 46 x 63 cm (18 1/16 x 24 3/4 in.). Gift of Mrs. Joseph Regenstein, 1964.243.

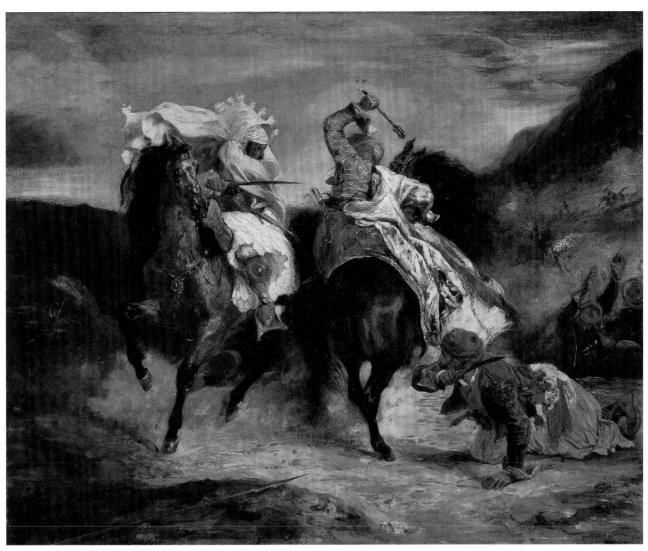

FIGURE 10. Eugène Delacroix (French, 1798–1863). *The Combat of the Giaour and Hassan*, 1826. Oil on canvas; 59.6 x 73.4 cm (23 ½ x 28 ⅞ in.). Gift of Bertha Palmer Thorne, Rose Movius Palmer, Mr. and Mrs. Arthur M. Wood, and Mr. and Mrs. Gordon Palmer, 1962.966.

The importance of distinctions between different local cultures and their respective individualities, the necessity to understand the deeply heterogeneous character of each local culture (even that of a community, not to mention a region or country), and the great need for intercultural communication while recognizing the difficulties of such intercourse.[14]

The variety of artworks discussed in this publication and the programs inspired by Silk Road Chicago provide magnificent evidence of the rich array of distinctive cultural traditions with which many people today can be so easily in contact. If the history of cross-cultural encounters provides tales that are both compelling and occasionally cautionary, the magnificence of the sites, objects, stories, and sounds that define those cultures (and those encounters) is a convincing explanation of why the regions of the Silk Road have mesmerized so many people for so many centuries, and why we have so much to learn from them still. Our task, and here Marco Polo might agree, is to make sure our ears—and our eyes—are perceptively engaged.

# The Silk Road and Beyond:
# A Conversation with James Cuno and Yo-Yo Ma

GREGORY NOSAN, Editor, *Museum Studies*: *One of the central aspects of Silk Road Chicago—and one that has shaped this publication in an important way—is a particular understanding of what the Silk Road means to us today. Can you tell us about this?*

YO-YO MA, Artistic Director and Founder, the Silk Road Project: When we talk about the Silk Road at the Silk Road Project, we use the term both historically and metaphorically. The term *Silk Road* has been used since the nineteenth century to refer to the historical network of trade routes that connected East Asia with the Mediterranean from about 200 B.C. to A.D. 1500. The Silk Road is also a wonderful metaphor: silk and other precious commodities moved from China to Europe, so the road on which those goods traveled came to be called for the goods themselves. Talking about a Silk Road evokes images of a road that's a precious ribbon, running from China to the Mediterranean, trodden by thousands of humans and camels.

But the term is metaphorical in another sense. We primarily use it to stand not just for the material goods that moved along it but also for the ideas that traveled in both directions. We use *Silk Road* to stand for the interconnectedness of peoples who were separated by vast distances, and indeed by decades and even centuries. I think that this commingling of history and metaphor is what makes the Silk Road such an evocative symbol of cultural exchange and connection.

JAMES CUNO, President and Eloise W. Martin Director, the Art Institute of Chicago: Absolutely. At the Art Institute, though, one of our challenges has been to figure out how to articulate—and even expand—these meanings without becoming confusing. On the one hand, we've tried to convey a sense of the historical Silk Road and its legacy by displaying objects from our collection that were produced along the ancient trade routes and that reveal mingling styles, techniques, and materials from different cultural traditions. We've also introduced audiences to more recent works like *Rapture* (see fig. 1), a powerful video installation by the Iranian-born, Berkeley-educated artist Shirin Neshat, as a way to suggest that the cultures of the Silk Road are of course very much alive—and that artists rooted in them are making work of the greatest importance. Neshat's rhapsodic and deeply moving composition is at once very local—concerned with issues of Iranian society and Muslim religious practice—and international, or even primordial. It's of interest to anyone who feels the striking content of its starkly contrasting images, which show men and women performing ritualistic actions.

On the other hand, however, we've decided to broaden the metaphorical significance of the Silk Road: at the Art Institute, we're using the term not only to suggest the ideas that traveled along the trade routes between East Asia and the Mediterranean but also many more of the ways in which cultures have connected and intersected

OPPOSITE: Yo-Yo Ma and James Cuno explain their vision of the Silk Road Chicago collaboration, November 2005.

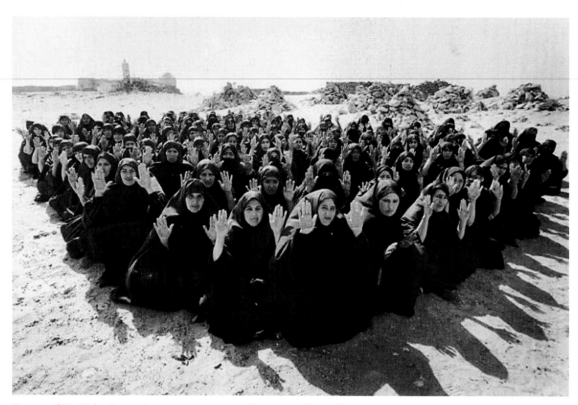

FIGURE 1. Shirin Neshat (Iranian, born 1957). *Rapture*, 1999. Two-channel video installation; duration 13 min. Howard and Donna Stone Collection, promised gift to the Art Institute of Chicago.

over time, everywhere. So in our exhibitions and in this issue of *Museum Studies*, we're including objects that were produced by societies all over the world, across a broad stretch of time, right up to today. We're also making a point of acknowledging that cultural interchange involved not only trade and intellectual borrowing but also conquest, exploration, colonialism, and religious missions and pilgrimages, all of which are interconnected, overlapping modes of contact—some harmonious, some not—that made their own imprint on the objects in our collection.

GN: *Silk Road Chicago is the Silk Road Project's most ambitious attempt at collaboration—not just with major cultural institutions but, through them, with an entire metropolitan area. Can you talk about how this citywide celebration has taken shape in Chicago and what you hope it might accomplish?*

JC: I think the vision of Silk Road Chicago—which is one of a whole city exploring its own capacity for collaboration on a grand scale—has inspired us to make the connections we've needed to, both between our respective organizations and

with the public. The Art Institute, the Chicago Symphony Orchestra, and the City of Chicago have each worked with the Silk Road Project, and with each other, in unprecedented ways. The number and quality of the events that have taken place has been simply extraordinary: literally hundreds of concerts, special exhibitions, and performances, many of them by Chicago actors, dancers, musicians, and visual artists. I like to think that the success of these programs, and the relationships that we've developed as we've planned them, will be things that we can return to in the future as we consider what public institutions like ours are capable of at our best and explore what other projects we might take on together. I also hope that Silk Road Chicago will give people experiences that they'll remember—an extended time when the city felt particularly exciting as a center of art and culture.

For me, one high point was the opening day of the Silk Road season at the Art Institute, when the museum was alive with over five thousand visitors who came for lectures, stories, gallery talks, and art demonstrations. There were also many performances, including those by the Silk Road Ensemble, the Chicago Children's Choir, and the classical

Indian dancers of the local Natya Dance Theater (see figs. 2–3). The sense of energy in the building that day was palpable. It captured so well, I believe, how civic institutions like the Art Institute can express the character of the audiences they serve. Chicago is a burgeoning, multicultural city of immigrants—this is true now, just as it was in the late nineteenth century, when the museum and the symphony were founded. My sense is that organizations like ours, and collaborations like Silk Road Chicago, provide new ways for us to explore and combine varied, vibrant forms of artistic expression and in the process get a clearer sense of who we are as a community.

GN: *What about you, Yo-Yo?*

YM: As Jim mentioned, Silk Road Chicago came out of conversations with the Art Institute, the Chicago Symphony Orchestra, and the City of Chicago. Initially, we were talking with the museum and the symphony about a shared residency over a week or two. In each conversation, the idea of the Silk Road resonated deeply, and each partner was able to imagine quickly what it would mean to them—for the Art Institute, exhibitions drawn from its collections along with complementary programs; for the Chicago Symphony, concerts around this theme throughout the year; and for the city, a summer of activities incorporating over seventy cultural groups. Each organization saw the value of Silk Road as a way to draw people together and for audiences to think about and understand the world around them, hopefully with new eyes.

At the Silk Road Project, we study the global circulation of music and musical ideas. We believe that one of the great artistic challenges of our time is to nourish global connections through new cultural developments, even as we're working to maintain the integrity of art that is rooted in authentic local traditions. We hope to do this in Silk Road Chicago, as we reconnect with the artists and traditions of the past, create new works in the present, and reach out

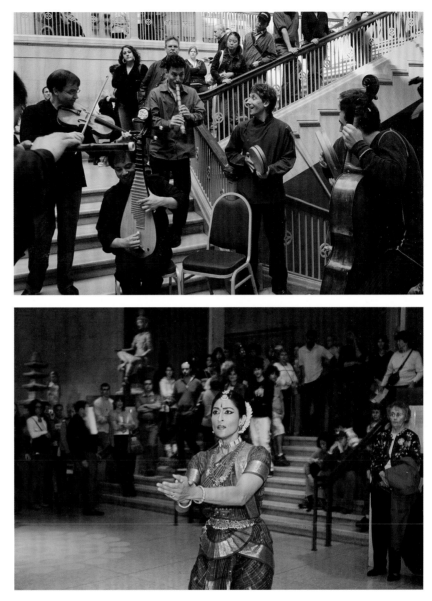

FIGURE 2. Members of the Silk Road Ensemble play on the Art Institute's Grand Staircase at the opening day celebration of Silk Road Chicago, September 2006. From left to right, Hu Jianbing, *bawu*; Nicholas Cords, viola; Yang Wei, *pipa*; Kojiro Umezaki, *shakuhachi;* Shane Shanahan, percussion; Mark Suter, percussion; and Eric Jacobsen, cello. FIGURE 3. Krithika Rajagopalan of Natya Dance Theater performs for visitors in the galleries.

to as many of the city's communities as we can. Silk Road Chicago is a creative collaboration with seemingly limitless potential: each partner wants to identify its own treasures and communicate them broadly, so that all of them can be shared. This requires an openness and generosity on the part of everyone concerned, and we have felt that spirit in this city from our first conversations about Silk Road Chicago.

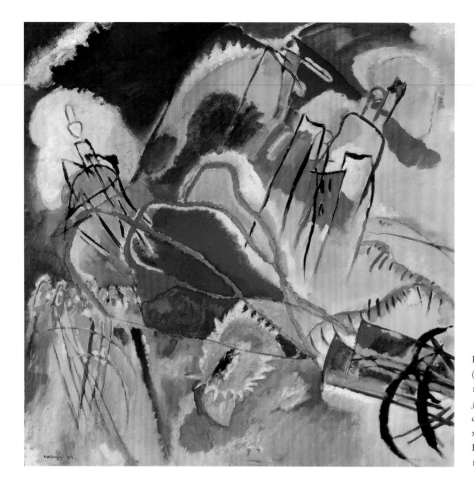

Figure 4. Vasily Kandinsky (French, born Russia, 1866–1944). *Improvisation No. 30 (Cannons)*, 1913. Oil on canvas; 109.2 x 110.5 (43 ¼ x 43 ¾ in.). Arthur Jerome Eddy Memorial Collection, 1931.511.

GN: *The Silk Road Ensemble's 2001 recording was titled* Silk Road Journeys: When Strangers Meet. *It occurs to me that Silk Road Chicago might be characterized as yet another instance of "strangers meeting"—at least in the sense of musical and visual cultures intersecting. Can both of you talk about what you see as being the differences and similarities of music and visual art's ability to register—or themselves be—the sort of cross-cultural encounter this project is interested in?*

YM: I'm glad you asked about this, and my first response would be to say that art and music are in many ways more similar than we might think. Let's take Kandinsky's *Improvisation No. 30 (Cannons)* (fig. 4), an Art Institute work I'm familiar with. I know that Kandinsky is usually considered a great proponent of abstract art, and that he wrote a book in 1912 called *Concerning the Spiritual in Art*, in which he discussed the psychological effects of color by drawing analogies between music and art. As I understand it, he was arguing that nonobjective art has meaning— that a triangle can have as much significance as a human

face. Nonobjective art may relate well to music, which is in its own way quite abstract. Very little music is strictly programmatic. And good performers must go far beyond musical technique, as important as that is. They must understand music's emotional and often abstract content, communicate that content, and see and feel the reception of that content in their audiences.

GN: *So you're really talking about music's ability to create a sort of emotional understanding between people who might not know one another at all?*

YM: Right. I think that music is one of the best ways human beings have invented to share emotions. Kandinsky talked about the relationship between the artist's immaterial emotion and the material he uses, resulting in the creation of a work of art. And then, if I understand it correctly, according to Kandinsky another relationship develops— between the material (the artist and his work) and the immaterial (the emotion evoked in the observer or, in the

24

case of music, the listener). This is exactly what I mean when I talk about content, communication of content, and reception of content. It is exactly what I hope for all the activities of Silk Road Chicago.

Making connections is really what the Silk Road Project and the Silk Road Ensemble are all about. I feel that we human beings have much more that connects us than separates us. Music offers one of the most vital ways to feel this interconnectedness—to loved ones and friends, community and nation. But what about connecting to strangers and to cultures that are far away, either geographically or in time? Might we better understand people who are radically different from us by listening to their music? In doing so, might we come to see and hear

them on a more human level? Can music help trust to develop? My answer is a resounding "yes."

GN: *Jim, do you envision works of visual art as operating on viewers in the same way?*

JC: I think the immediate, emotional connection with a work of visual art is extremely important—most often sparked by aesthetic attraction. It's that feeling we have of being drawn to an object because of its intrinsic beauty, or some other quality of line, shape, color, narrative content, or evidence of the artist's hand, that intrigues or moves us. I don't need to know much about the artist or the subject of an object to be intrigued by it. All great art is alluring: it

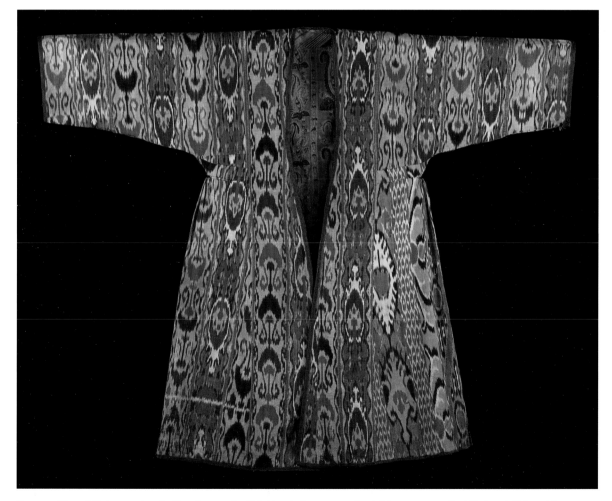

FIGURE 5. *Woman's Robe*, 1840s/60s. Bukhara (present-day Uzbekistan). Cotton, warp-faced plain weave; warp-dyed (ikat); main lining: plain weave; printed; center opening lining: warp-faced plain weave; bottom edge lining: plain weave; cuff lining: 2:1 twill weave; edging: warp twining; 134 x 167.5 cm (52 $^{13}/_{16}$ x 54 in.). Gift of Guido Goldman, 2005.606.

attracts our attention and stimulates our imagination. We want to know more about it. In the case of the Kandinsky (fig. 4), for example, what are those landscape forms in the painting? And why is there seemingly a hilltop town in the upper right, a pair of cannons in the lower right, and what seems like perhaps an army to the left? Do the explosive, colored forms suggest human combat or the age-old, mythical reenactment of the triumph of right over wrong? On what register of human emotion is this painting playing? It seems to me that artworks, like music, provide us with a way to connect, on a very emotional level, with people and cultures that may be far distant or long dead.

YM: Yes—I was also very moved when I looked at the woman's robe from Bukhara (fig. 5) that entered the Art Institute recently. What a beautiful, multilayered piece. This robe comes from present-day Uzbekistan, but it was woven 150 years before Uzbekistan became an independent country in 1991. Central Asia was in turmoil in the mid-nineteenth century, as European powers wrestled for control. But the weavers who made this robe were working with centuries-old weaving traditions that transcended the

geopolitical struggles of their day. Looking at that piece just reinforced my sense that art and music have the ability to help us tap into something bigger than ourselves.

JC: I think it's both wondrous and natural that human beings, however horrible their situation is—whether it be in nineteenth-century Uzbekistan or in Darfur right now—adorn their daily lives with great beauty. What made someone invest the time, energy, and capital in making a robe that could just as easily have been plain and simple? That's what I find so moving about this piece or any number of adorned utilitarian things: people have always cared about beauty. And as we care about beautiful things, and can be moved by the beauty of this robe, we can begin to understand the past—the past of the people who lived in that place, that culture, at just that time, when their world was at the center of a trade network of dazzlingly strange and beautiful things.

We know that artists have always been influenced by other artists and cultures—nothing of consequence has ever been made in isolation. Artists, indeed all of us, are sensitive to new things and places, and we can't help but be attracted to

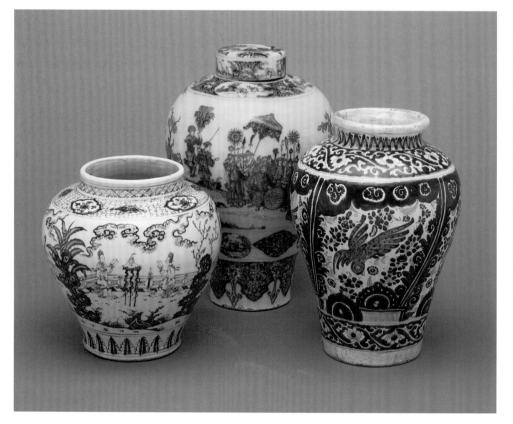

FIGURE 6. Left: *Jar with the Four Polite Accomplishments.* China, Ming dynasty (1368–1662), reign of Xuande (1426–36). Porcelain painted in underglaze blue; h. 35.6 cm (14 in.). Bequest of Russell Tyson, 1964.693. Center: *Vase with Cover,* 1675/80. Attributed to Greek A Factory, Delft, the Netherlands. Tin-glazed earthenware; h. 58 cm (23 in.). Anonymous gift in honor of Eloise W. Martin; Eloise W. Martin Fund, 1998.515a–b. Right: *Vase,* c. 1750. Puebla, Mexico. Tin-glazed earthenware; h. 49 cm (19 ¼ in.). Gift of Mrs. Eva H. Lewis in memory of her husband, Herbert Pickering Lewis, 1023.1445.

them. What scholarship helps us do, however, is better appreciate the specific nature of that influence—and of innovation, too. A great example of this is the story of blue-and-white ceramics. By the tenth century, Iraqi potters figured out how to use cobalt compounds to decorate their works with a rich, blue color. This technology then spread to China, which began producing blue-and-white porcelain for export beginning in the 1300s. By the sixteenth century, these wares were being traded around the world. Portuguese ships carried large quantities to Europe, where artisans in different countries began producing their own versions of blue and white. Meanwhile, Spanish galleons sailing from the Philippines transported Chinese porcelain to Mexico, where potters created *their* own unique variation. So, even a few apparently similar blue-and-white jars reveal—once we know a bit more about them—how trade influenced the transmission of taste and technology over centuries and across vast distances (see fig. 6).

YM: Many of us at the Silk Road Project have been fascinated by the global circulation of blue and white as a quintessential Silk Road story. In fact, in April 2007 several of our ensemble members are premiering a multimedia performance at the Art Institute that's based on blue-and-white themes. In the work, original music accompanies film footage of children encountering blue-and-white ceramics in a museum; visual images of blue and white, including many pieces in the Art Institute; and stories about blue and white, including a Japanese tale about a hapless serving girl who was accused by her master of breaking a precious plate. Her plight was brilliantly captured by the nineteenth-century artist Hokusai in a famous woodblock print.

GN: *Yo-Yo, would you say that the sort of global circulation we're discussing occurs in the history of music, too?*

YM: Yes, but what really comes to mind is the history of musical instruments. I actually know of two paintings in the Art Institute's collection that illustrate this wonderfully: *The Music Lesson* by Jacob Ochtervelt and *Seventeenth-*

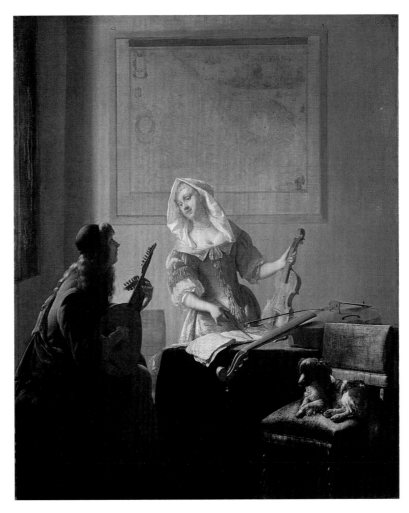

FIGURE 7. Jacob Ochtervelt (Dutch, 1634–1682). *The Music Lesson*, 1671. Oil on canvas; 80.2 x 65.5 cm (31 x 25 3⁄16 in.). Mr. and Mrs. Martin A. Ryerson Collection, 1933.1088.

*Century Interior* by Charles Gifford Dyer (front cover and figs. 7–8). Both of these works feature a lute—an important instrument in seventeenth-century European musical life. The lute is related to the Chinese *pipa* in a fascinating way: both are ultimately descended from a Central Asian instrument, the *barbat*, which traveled to China along the Silk Road about two thousand years ago. In time, the *barbat*, which had four strings, developed into the four-stringed *pipa* and the Japanese *biwa*. The *barbat* also traveled west, where it was adopted by the cultures of West Asia. Its name changed to *oud*, the Arabic word for wood, which was what the instrument was made out of.

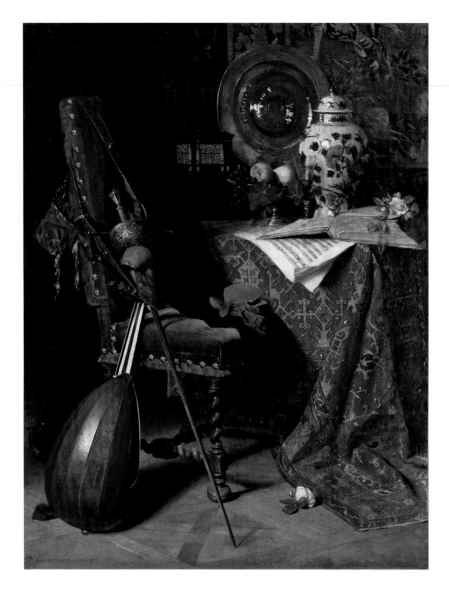

FIGURE 8. Charles Gifford Dyer (American, 1846–1912). *Seventeenth-Century Interior*, 1877. Oil on canvas; 94 x 71.1 cm (37 x 28 in.). Gift of Henry W. King, 1902.227.

After the Muslims conquered North Africa and Spain beginning in the eighth century, the *oud* entered Europe. In fact, the European word *lute* derives from the Arabic *al oud*. So, while the inhabitants of Dyer's richly appointed room admired their blue-and-white jar and oriental carpet, they may not have known that their lute was also indebted to trade, travel, and cross-cultural exchange between Asia and Europe.

GN: *Jim, why do you think the Silk Road has become such a focus of popular fascination and scholarly interest in our own time? What do we see of ourselves in it, and what does it help us understand about how we live?*

JC: We live in an especially interrelated world. Travel and broadcast communication—and of course the Internet—have dissolved the obvious barriers of time and distance. We are all aware of other cultures, and to a remarkable degree. Part of what I think appeals to us about the historical Silk Road, with all of its cultural mixing and borrowing, is that it offers us a different way to understand our own historical moment. Ours is an age of resurgent nationalism. The break-up of empires, from the Ottoman to the British and Soviet, and the success of independence movements after World War II, have propagated the view of people as divided into nations comprising "pure" ethnic or cultural characteristics. However, as the historical Silk Road shows us time and again, nothing in the world's history argues in favor of this. We are defined as a species by our ability, indeed compulsion, to adapt by accepting influences, modifying them, and creating new conditions. Anthropologists call this *hybridity*. Ancient Roman authors, who were less kind, called it *contamination*.

I agree with the philosopher Kwame Anthony Appiah, who argues against the notion of purity and in favor of contamination as a condition of cosmopolitanism, which he holds to be truer to the human condition than the utopian ideal of ethnic and cultural purity. I believe strongly that museums like the Art Institute are instruments for the dissolution of superstition and prejudice. Our very collections work this way. They are manifestations of hybridity and contamination. They give evidence of artistic influence and cultural interrelatedness. And they are what allow us to call ourselves a humanist enterprise—in the sense that Edward Said described humanism when he referred to it in *Orientalism* as "the final resistance we have against the inhuman practices and injustices that disfigure human history."

GN: *Jim, you've talked before about how you believe that Silk Road Chicago offers visitors "alternative ways" to access the Art Institute's collections. What do you think adopting such alternative approaches does for museums like ours, both as an interpretive choice and as a decision that changes the experience of our visitors in important ways?*

JC: Like most museums, we now offer access to our collections primarily by chronology, cultural area, and media. But there are other ways to experience objects: we can encourage the appreciation of alternative connections across time and space, in terms of color, iconography, materials, or ornament, for example, without radically altering our installations. The very themes of this publication—travel, trade, and transformation—are an example of this approach at work.

By focusing on objects in our collection and asking our visitors to look at them differently—particularly in terms of how they show signs of having been made in light of various artistic influences that contradict the simplistic, modern definitions of cultural purity—we'll be true to the objects themselves and the history of their making and subsequent history in the world.

At the Art Institute, this has required us to try and slow people down and encourage them to look afresh at objects in our collection, to be drawn to them, and to ask new questions about them. It has also required us to reconsider what we possess, focusing new attention on those artworks that embody hybridity in different, powerful ways. One of my favorite examples is a fourteenth-century German reliquary that incorporates a rock-crystal perfume bottle made in Fatimid Egypt (fig. 9). While this is one of the museum's treasures, it's also a great example of an object that, as a consequence of trade, underwent a transformation that's at once literal and metaphysical. As Egypt's Muslim rulers sold off their collections of carved rock crystal in the 1060s, personal luxury items like this one found their way to Europe. This bottle was redeployed in quite a different way, becoming a transparent vessel for a saintly relic, an extremely precious object to a medieval Christian.

Another benefit of Silk Road Chicago is that it gives us an important opportunity to remind visitors that the Art Institute is, in fact, an encyclopedic art museum—that we hold in trust for them a significant part of the world's shared artistic legacy, with a permanent collection that is rich and deep across all of our curatorial departments. We're not only a venue for important special exhibitions,

but are, first and foremost, a resource that is available, every day, to the public, whether they are residents of Chicago or not. I think that Silk Road Chicago has helped us advance our mission as an encyclopedic museum, and that one of the most exciting aspects of this project has been how it has challenged us, as art historians and educators, to work together to find inventive ways of displaying the objects in our care, helping visitors discover the many stories they tell and the many ways they matter.

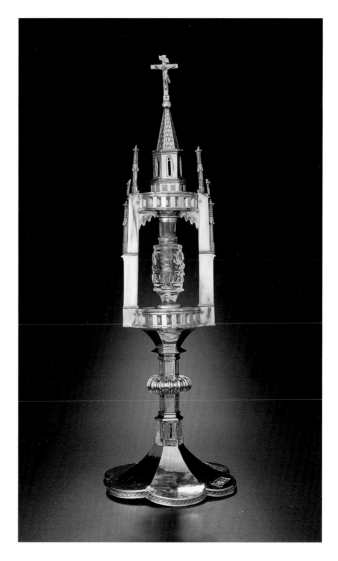

FIGURE 9. *Monstrance with Tooth of Saint John the Baptist*, 1375/1400. Brunswick, Germany. Gilt silver; 45.5 x 14.6 cm (17 ⅞ x 5 ¾ in.). *Rock Crystal Bottle*, 900/1000. Egypt, Fatimid dynasty (909–1171). Gift of Mrs. Chauncey McCormick, 1962.91.

چو اسکندر آمد وزیر ... ... ... ... ... کای شاه پیروز مش ... ... ... یکشتمت دشمنت ... ... ... رانا کهان ... ... ... ... ... سر آمد بر ن ... ... ... و تخت جها ...

سکندر چنین گفت بالا میار ... ... ... که دشمن که افکندی اکنون کجا ... ... ... بید کشار جاو ... ... شینلد ... ... ... باید نمودن بار ه را ا ...

دل و جان رومی پر از خشم و خو ... ... ... جو نزدیک شد روی دا راید ... ... ... شد مهر دو بر پیش اندرو ... ... ... پر از خون بر و روی جون ...

دو دست ور او راکمه د ... ... ... شد ... ... ... سکندر زا سب ا ذر آمد جبا ... ... ... دا ره بکمه ا ششش ... ... ... سر مرد جسته بران بر نها ...

ناخسته کو بیده پ ... ... ... ست

با بید بر جر او سر رود پ ... ... ست

# Travel

WHILE THE OBJECTS presented in this section were produced in many cultures over a period of more than two millennia, they all reveal the central role of travel in determining the shape of our aesthetic experiences, which are often political and spiritual as well. Some artworks, such as Melchior Lorichs's portrait of a Persian ambassador (p. 42) and Art Spiegelman's *Crossroads* (p. 49), are created to document or otherwise make sense of a journey from one place to another, whether it be a religious or diplomatic mission, or a displacement caused by war. Others, like the Tang horse from eighth-century China (p. 32), or Pisanello's sketches of the Byzantine emperor John VIII Paleologus and his retinue (pp. 40–41), are responses to the presence of someone or something novel from abroad. More subtle yet are objects such as the Crusader diptych (p. 44), the portrait of Kōbō Daishi (p. 45), or the European banquet scene (p. 47), which make no explicit reference to other cultures but reveal in their style, subjects, and, sometimes, their very existence, the spread of ideas, beliefs, and visual traditions across time and space.

Three works in this section that illustrate travel's often interwoven aesthetic, political, and religious effects particularly well were all made in the wake of Alexander the Great's circuitous journey from the shores of the Mediterranean Sea to the Indus River. When he crossed from Europe into Asia with his army in 334 B.C., the young Macedonian king's primary goal was to topple the mighty Persian Empire ruled by Darius III. After traveling to Egypt to liberate the country from Persian dominion, he took it—and the title of pharaoh—for his own. The Art Institute's silver coin (p. 33), which shows him wearing an attribute of the Egyptian god Ammon, demonstrates one of his attempts to both reconcile and exploit the differing religious beliefs and practices of the cultures he ruled.

Upon leaving Egypt, Alexander resumed his imperial conquest. Soon Darius lay dead, and his empire fell to Alexander, who sought to create political stability in the region through the intermarriage of Macedonians and Persians. To this end, he wed a Persian princess, ordered his highest officers take noble brides, and encouraged his troops to marry local women. By the time the Persian poet Firdausi composed the epic *Shahnama* (Book of Kings) some 1,300 years later, Alexander's name and appearance had been substantially transformed. In the story, and in the Art Institute's fifteenth-century illustration of one of its crucial scenes (opposite and p. 35), he is remembered not only as a benevolent conqueror but also as half-Persian himself, which suggests both the success of his plan and the extent to which art and literature do more than merely record history, rewriting it on their own terms. After accomplishing his goal, Alexander did not return home but campaigned across Central Asia until he reached India. Along the way, he and his troops settled a number of towns, where the merging of Greek and local visual cultures resulted in imaginative new forms and styles. One example of these is the sculpture of a bodhisattva carved in the second or third century B.C. (p. 34). Working in the crossroads region of Gandhara, its makers blended Hellenistic, Indian, and Central Asian influences, mingling religious and secular artistic traditions into an object that, like so many in this section, constitutes a truly hybrid work of art.

OPPOSITE: Detail of *Alexander Comforts the Dying Darius* (p. 35).

31

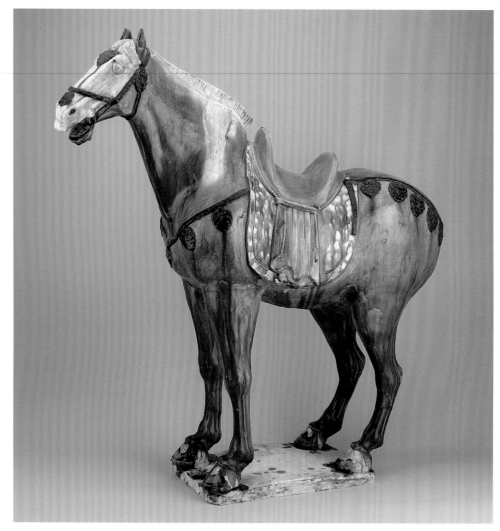

*Horse*
First half of the 8th century
China, Tang dynasty (618–907)
Earthenware with three-color (*sancai*) lead glazes
77.5 x 25.5 x 71.5 cm (30 ½ x 10 x 28 ⅛ in.)
Gift of Rose Movius Palmer, 1981.1212

Throughout China's history, the security of its northern and northwestern frontiers required swift, powerful, and resilient horses. The country's earliest domesticated steeds were stocky animals descended from wild breeds that had roamed its borderlands in prehistoric times; these served primarily as draft animals and to pull chariots.[1] But the Chinese were rendered defenseless by cavalries of militant nomadic tribes who bred strong horses along the eastern Eurasian steppes and who, by the ninth century B.C., had penetrated into northern China. Six centuries later, the fierce Xiongnu, who were masters of mounted archery, descended from the Ordos Plateau to attack the newly established Han dynasty (206 B.C.–A.D. 220), thereby impressing upon China's rulers the urgent need for robust horses.[2]

In the course of perilous military expeditions westward to expand territory and to establish alliances with the Xiongnu's rivals, Chinese envoys discovered purebred horses from the Ferghana Valley of present-day Uzbekistan. Following four years of protracted and brutal warfare, Han armies negotiated the trade of silk fabrics, among other commodities, in exchange for strong stallions. The ensuing traffic, which through a series of intermediaries transported Chinese textiles to the Roman Empire, signaled the opening of the overland Silk Road.[3]

After the four centuries of fragmentation that followed the collapse of the Han ruling house, Tang dynasty China emerged as the world's most prosperous and expansive empire. While aristocrats coveted powerful steeds for hunting, polo, and other sports, cavalrymen required them for armed expeditions and defense of the realm's burgeoning but vulnerable borders.[4] Through military force as well as payment in currency, silk, tea, wine, and even royal princesses, Tang rulers and traders sought superior horses from sources near and far, including Turks and Tibetans encircling the empire's northwestern frontiers and rulers of kingdoms and city-states as far west as the Aral Sea and the Iranian Plateau. The finest breeds were reserved for government and military stables.[5]

The Tang elite commissioned clay models of horses to accompany them in the afterlife. Unusually large and handsome examples such as this have been excavated from cemeteries surrounding the capitals of Chang'an (present-day Xi'an) and Luoyang; specially placed within tombs, they were often paired with figures of Central Asian grooms and juxtaposed with camels of comparable scale (see p. 13).[6] Together with other ceramic sculptures, this steed was designed to be flaunted in an extravagant funerary procession and then interred to create a familiar, protective environment for the deceased.

ELINOR PEARLSTEIN

### Tetradrachm Portraying Alexander the Great
Reign of Lysimachus of Thrace (306–281 B.C.)
Greek, made in Ephesus
Silver; diam. 3.1 cm (1 ¼ in.)
Gift of Martin A. Ryerson, 1922.4924

Keenly aware of the power of imagery among people who were largely illiterate but visually perceptive, Alexander the Great (356–323 B.C.) carefully controlled the way he was portrayed. In so doing, he unwittingly established an iconography for royal portraiture that would endure for centuries.[1] His concern about his own representation extended beyond the major arts of sculpture and painting to miniature portraits on coins. On this tetradrachm, the Macedonian king is depicted in his preferred manner: youthful and clean-shaven, with eyes glancing heavenward and long locks of hair rising above his forehead. Around his ear curls a ram's horn, symbol of the Egyptian god Ammon, whom the Greeks equated with Zeus.[2]

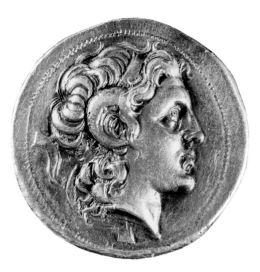

The coin commemorates an important event that took place in the winter of 332 B.C. Having already routed the mighty army of the Persian emperor Darius at Issus, freed the Greek-speaking cities of western Asia Minor, and captured the Phoenician seaport of Tyre, Alexander marched into Egypt, where—encountering no resistance—he was declared pharaoh. But rather than immediately pressing onward in his quest to conquer the Persian Empire, he left his army encamped near the Nile and set out on a journey across the harsh Libyan desert to the oasis of Siwa, home of the oracular shrine of Ammon. The king had come to talk to the deity. Only those who were present knew what actually transpired, but ancient historians reported that Ammon's high priest greeted Alexander as the "son of god."[3]

The Egyptians had long accepted the divinity of their pharaohs as an indisputable fact; while the Greeks were less inclined to believe such claims, they were not above making them when it suited their purposes. Alexander, who was obsessed with his legacy, exploited his supposedly divine descent for propagandistic reasons, and so did his successors when they began to stake out territory and consolidate power after his death in Babylon in 323 B.C. For example, more than sixteen years later, Alexander's former bodyguard and companion Lysimachus took northern Greece for his empire and then issued a series of coins such as this one, which blends Egyptian symbolism with Greek iconography, equating the mortal Alexander with the divine Ammon.[4] By adding his own name and the title of king to the reverse of the coin, Lysimachus reinforced his right to rule by emphasizing his own personal relationship with the god incarnate.

KAREN MANCHESTER

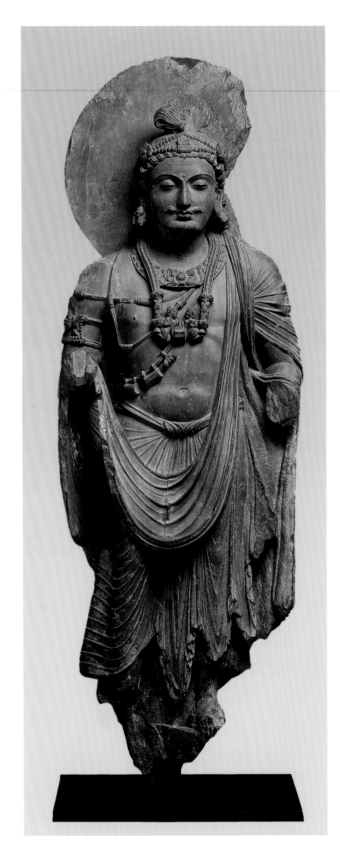

*Bodhisattva*
2nd/3rd century
Gandhara (present-day Pakistan)
Schist; 150.5 x 53.3 x 19 cm (59 ¼ x 21 x 7 ½ in.)
James W. and Marilynn Alsdorf Collection, 198.1997

In the ancient world, military movements between Persia, Central Asia, and India were channeled through Gandhara, a strategic region of plains and valleys bordering the Hindu Kush mountain range in present-day Afghanistan and Pakistan. Gandhara's history encompasses that of the empires that ruled it: it was a province of the Persian Empire, a conquest of Alexander the Great on his eastern campaign of 327–26 B.C., and part of the Mauryan Empire in India in the following century. By the early centuries A.D., Central Asian tribes such as the Yuezhi (later known as the Kushans) began to overtake the region, and Gandhara became an empire of its own, establishing itself as an independent Kushan state. During this period of prosperity, the arts thrived with a creativity that was based on Gandhara's long exposure to different ethnic and cultural groups.

The Kushan period (first–third centuries) sparked a florescence of Buddhist sculptural tradition in Gandhara, propelling the religion in new spiritual directions and giving rise to some of the earliest depictions of the Buddha.[1] This image, finely modeled from local stone, represents a bodhisattva, an enlightened being who chooses to stay in the cycle of death and rebirth as a spiritual guide for others. He acts as the eternal helper of the Buddha, embodying his boundless mercy and compassion. The unique conception of the bodhisattva in Gandharan art stands in sharp contrast to those of earlier Buddhist traditions, which avoided depicting the human form.[2] The simplicity of this figure's orblike halo frames a face of inward concentration, reminding viewers of his enlightened state; it is likely that his right hand originally displayed a gesture of reassurance to the faithful.[3] However, his sumptuous adornments emphasize the bodhisattva's earthly connection, revealing to seekers of enlightenment that he has postponed the fulfillment of his own spiritual reward.

In addition to projecting the values of Buddhism, this work represents the complex synthesis of Hellenistic, Indian, and Central Asian influences that is characteristic of Gandharan art. The dramatic draping of the figure's garment and the underlying musculature of his chest are clearly derived from Greek sources; his elaborate jewelry

suggests the regal conventions of an Indian prince; and his large halo may be of Persian origin.[4] The garment itself probably represents fine silk fabric, a commodity that often passed through Gandhara as it was transported along the Silk Road.

TANYA TREPTOW

## *Alexander Comforts the Dying Darius*
1480/90
Persia (present-day Iran)
Opaque watercolor and ink on paper
31 x 21.6 cm (12 3/16 x 8 ½ in.)
Gift of Ann McNear, 1976.525

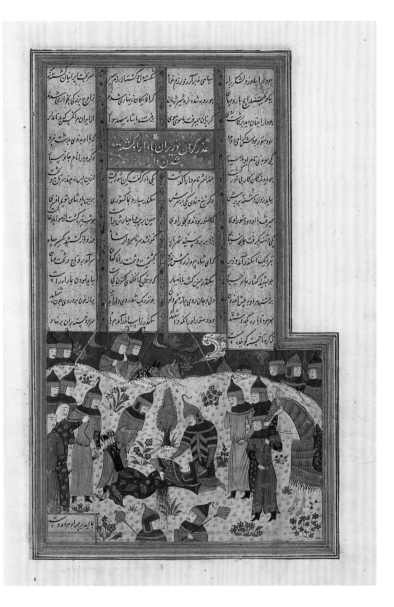

While the imperial ambitions of Alexander the Great had an immediate impact on the ancient world, they also reverberated over many centuries, since memories of him remained strong through almost all of the regions in which he campaigned. For example, long after his conquest of Persia in 334–330 B.C., he was celebrated as the hero Sikandar or Iskandar in the *Shahnama* (Book of Kings), a famous epic by the eleventh-century poet Firdausi, who documented the history of Persia from its mythological origins to the Islamic conquests of the seventh century.[1] Alexander's defeat of the Persian emperor Darius, depicted in this fifteenth-century manuscript, is one of the work's most popular dramatic moments.

The *Shahnama* tells how, after the rout of his army, Darius was stabbed by two of his own men, who hoped to gain favor with Alexander. He lies at the center of this scene, looking up at Alexander, unable to stem the stream of blood flowing from his side. Alexander, wearing a red garment embroidered in gold, has just recognized the treachery of Darius's men and now approaches the emperor, nobly promising to punish the assassins and restore his power. Although Darius dies from his wounds, those who watch are amazed at Alexander's compassion toward his enemy (indicated here by a single finger lifted to the mouth).

The Turkman style of this painting, with its simple composition, effectively conveys the bold actions of the story. Strong, contrasting colors create a balanced effect that frames and highlights the central figures. At the same time, the heads of soldiers peer out from behind the hill, adding depth by suggesting a world beyond the borders of the page. Some of these men must be Europeans, but they all appear with Eastern features, a visual convention typical of Central Asian influence in fifteenth-century Persia.[2]

In the *Shahnama*, Firdausi cleverly justified Alexander's conquest and at the same time fully appropriated it in the service of his own, native historical narrative, creating a unique memory of Alexander as a king who upheld and glorified the ideals of Persian government, society, and morality. Furthermore, the poet gave Alexander a natural right to the throne by identifying him as Darius's older half-

brother. This version of the Alexander story does not exist in isolation; rather, it draws on a long fascination with Alexander in the Middle East, seen in earlier texts such as the *Alexander Romance* of third-century Egypt and the *Christian Legend Concerning Alexander* of sixth-century Syria.[3]

<div align="right">TANYA TREPTOW</div>

### A Season Outside

1997
Amar Kanwar (Indian, born 1964)
Film transferred to digital video disc
number 2 of an edition of 6; duration 30 min.
Restricted gift of Martin Friedman and Peggy Casey-Friedman;
Contemporary Art Discretionary Fund, 2004.481

In 1947 the British government carved its imperial holdings on the Indian subcontinent into two nations based on the region's dominant religions, establishing Hindu-majority India and Muslim-majority Pakistan. This division, known as Partition, left millions of people on the wrong side of a border, causing immediate rioting and killing, violence that has escalated over the last fifty years into an arms race. Simultaneously, the legacy of Mahatma Gandhi has been diminished in India by a ruling party opposed to his policies and methods, which were defined by nonviolent resistance to British control and his attempts to reconcile distinct classes and religions in the region—especially Hindus and Muslims. His influence secured the region's independence, but Gandhi was unable to prevent Partition.

Amar Kanwar's *A Season Outside*, a subtle and poetic film written and narrated by the unseen artist, evokes

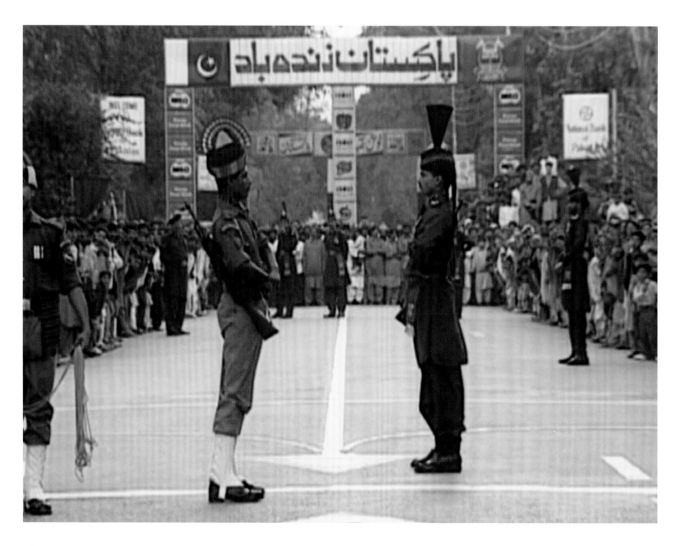

Gandhi's teachings and presents an introspective, philosophical monologue about the nature of nonviolent resistance. Kanwar juxtaposes his personal reflections with images of enforced division, theatrical military posturing, and reenacted—and then, finally, real—violence. The work opens with the sunset ritual regularly performed on the India-Pakistan border at Wagah-Atari, where military personnel engage in displays of nationalistic aggression before crowds of spectators on either side. This staged conflict, enacted in the public sphere and accompanied by the artist's voiceover, which quietly intimates that violence also occurred in his own home, shows how pervasively physical aggression may infect both cultures and individual human minds.

While *A Season Outside* seems to be a documentary, it is presented in an abstracted manner more conducive to an aesthetic or emotional effect than to exposé.

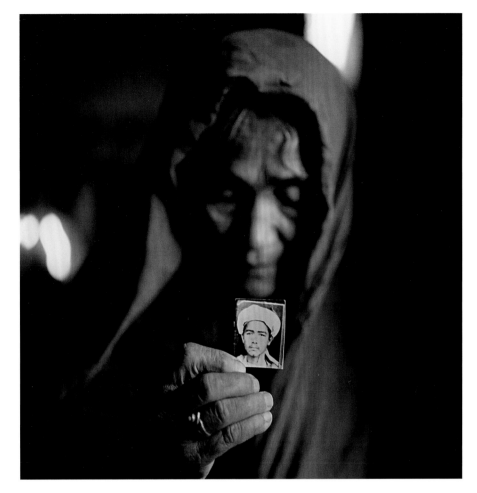

The film's poetic audio track bears a direct but entirely nondidactic, nonjournalistic relationship to its imagery. While Kanwar used his voice to address unflinchingly, in the most personal terms, the human impulse for violence—in particular when two cultures are brought into conflict as a result of arbitrary political borders—his visual approaches to the subject are indirect, through metaphorical or reenacted violence. The film's title denotes a space or time removed from the brutality depicted within, perhaps a note of hope that, at some point, there might exist a possibility for peaceful cohabitation, if not reconciliation.

LISA DORIN

## *Qurban Gul Holding a Photograph of Her Son Mula Awaz, Khairabad, Northern Pakistan*

1998

Fazal Sheikh (American, born 1965)

Toned gelatin silver print; 37.2 x 37.4 cm (4 ⁵/₈ x 14 ¹¹/₁₆ in.)

Horace W. Goldsmith Foundation Fund, 2002.71

In 1996, driven by a desire to better understand the long-dead grandfather whose name he bears, the American-born photographer Fazal Sheikh traveled to the land of his namesake's birth—Pakistan, then part of India. There he met displaced Afghans living in refugee communities across the eastern border of their country. Following the Soviet invasion in 1979, the subsequent uprising of the Mujahadeen, and the Taliban's seizure of power, many Afghans emigrated into neighboring Iran and Pakistan. By 1990, at the peak of the refugee crisis, nearly half the

Afghan people—6.2 million—had fled the country; in 1997, 2.7 million of these were still living in exile. During several journeys over two years, Sheikh listened to the refugees' tales of loss and endurance, recording their dreamlike yet terrifying recollections of life in their homeland.

One such person was Qurban Gul, who appears here holding a picture of her youngest son, Mula Awaz. In his book *The Victor Weeps*, Sheikh preserved her story: the eighteen-year-old Mula Awaz was killed in 1986 during an exchange of fire between the Soviets and the Mujahadeen. Before news of his death had reached her, Qurban Gul dreamed that her son's body was being washed and wrapped in white funereal cloth and then buried with his head pointed toward Mecca. She dreamed about him a second time, many years later, when she herself was ill and near death in a hospital. In that dream, Mula Awaz comforted his mother with a scarf that he removed from his shoulders and wrapped around her; in the coming days, Qurban Gul related, she recovered from her illness and returned home.[1]

In many of Sheikh's pictures from this series, the Afghan refugees hold up their own photographs, images of loved ones or of themselves in an earlier, perhaps more peaceful, time. They clutch these small, precious talismans with pride, secrecy, fear, yearning. For them, photographs—then, ironically, outlawed by the Taliban for violating Sharia Law against creating idols—became proof of existence, relics of the past, and comfort in exile. "As the world spins impossibly out of control around them," Sheikh wrote, "Afghans look further inward, narrowing their scope of vision to their own friends and families to find the spirit that will sustain them."[2]

<div align="right">ELIZABETH SIEGEL</div>

## *Adoration of the Magi*

1485/95
Attributed to Raffaello Botticini (Italian, 1477–c. 1520)
Tempera on poplar panel; diam. 104.2 cm (41 in.)
Mr. and Mrs. Martin A. Ryerson Collection, 1937.997

In the Renaissance and earlier, travel and the exchange of gifts were important aspects of diplomacy. Here, the three Magi have traversed great distances to Bethlehem, bringing presents to the divine king, the infant Christ. The unusual, nautical allusion to their passage—a large sailing vessel at left—probably reflects an account of their voyage provided in a popular thirteenth-century book, the *Golden Legend*

by Jacobus da Voragine, which describes how the Magi docked their boat in a port.[1]

To emphasize the trio's distant origins, artists frequently depicted many exotic figures, animals, and objects in their representations of the Procession or Adoration of the Child. In this picture, the painter has portrayed the actors in turbans and eccentric hats, and there is a group of black men, perhaps the retinue of the Magus Balthazar, at the far right. Surprisingly, a giraffe appears behind them in the distance. Not long before this work was executed, the Sultan of Egypt sent a giraffe as a gift to Florence's de facto leader and patron of the arts, Lorenzo de' Medici; the animal became the centerpiece of Lorenzo's menagerie and a favorite mascot of the Florentine people until it tragically struck its head on a low beam in the Medici Palace. The giraffe is joined in the painting by other exotic creatures, notably an ape and a peacock. These are intended not only to refer to distant lands but also to serve as religious or moral symbols. The ape, tethered at bottom left, was considered to be among the lewdest of beasts and stands for a sinful pre-Christian world. From the Middle Ages on, the peacock, perched high at upper right, was employed as a symbol of Christ and immortality, because it was believed that after the bird died its flesh did not decay.

The grand scene takes place within the remains of a colossal, antique temple. Such ruins typically appear in Renaissance depictions of the Adoration, where they are meant to suggest the Old Dispensation of the Jews, supplanted by the New Law under Christ. The structure is possibly intended to represent the Templum Pacis in Rome, which, according to the *Golden Legend*, contained a statue of Romulus that collapsed on the night of Christ's birth. The Florentine painter of this panel, who perhaps was not very familiar with ancient Roman architecture, took certain liberties with the building's decorations. He ornamented the fanciful, square columns in the foreground with what are called "grotesque" designs, after the rich and elaborate motifs found on the walls of the emperor Nero's then recently excavated, first-century Domus Aurea (Golden House), originally thought to be a grotto.

<div align="right">LARRY J. FEINBERG</div>

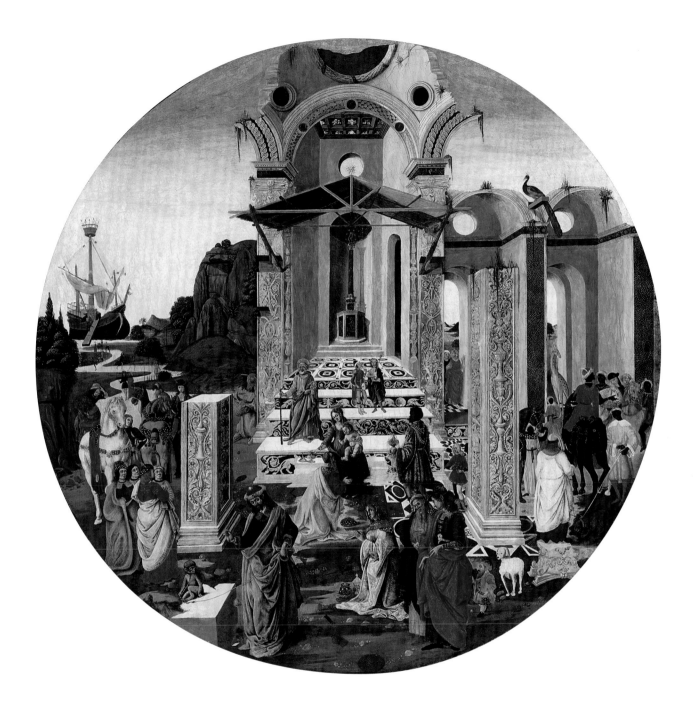

*Sketches of the Emperor John VIII Paleologus,
a Monk, and a Scabbard* (recto)
*Bow Case and Quiver of Arrows* (verso)

1438

Antonio Pisano, called Pisanello (Italian, c. 1395–c. 1455)

Pen and brown ink on ivory laid paper

18.9 x 26.5 cm (7 7/16 x 10 7/16 in.) max.

Margaret Day Blake Collection, 1961.331

Few objects in the Art Institute symbolize the depth of interactions between East and West more intimately than this outstanding double-sided folio. Described as a "rare treasure for an American collection," the sheet was drawn in 1438 by Pisanello, one of the greatest artists of the early Renaissance in northern Italy.[1] The occasion was the Council of Florence, called by Pope Eugene IV to unify the Greek and Latin churches.

Once part of a sketchbook, this sheet represents a unique visual record of the council.[2] The recto, below, most likely displays a spontaneous ensemble of free and immediate sketches of John VIII Paleologus, the penultimate Byzantine emperor and head of the Greek delegation, who is shown on horseback at left and standing in a different exotic costume at right. In the center is a Byzantine ecclesiastic, seen from behind; a scabbard appears at top. On the verso, at right, the artist indulged in a meticulous description of a Mamluk or Ottoman bow case and a quiver of arrows, probably part of the sovereign's magnificent hunting gear.[3] The representation of these intriguing figures and preciously decorated objects directly recalls the refinement of Eastern culture and the great fascination it inspired in Western artists.

From the Middle Ages on, contact between the Italian Peninsula and the Near East was lively and multifaceted although not always peaceful. Because of its strategic

Italian visual arts. Pisanello, above all, embodied "the triumph of observation and realism over the conventional symbol."[6] At the turn of the fifteenth century, with the presence in Venice of artists such as Gentile Bellini—who had painted at the court of the Ottoman sultan Mehmet II—Albrecht Dürer, and Giovanni Mansueti, to mention but a few, this tendency evolved into what has been described as a fully formed "Oriental Mode."[7]

LUCIA TANTARDINI LLOYD

### Ismael, the Ambassador of Tahmasp, King of Persia

1569
Melchior Lorichs (Danish, 1527–after 1594)
Engraving, on paper; plate: 39.5 x 26.5 cm (15 ½ x 10 ⁷/₁₆ in.), sheet: 41 x 31 cm (16 ¹/₈ x 12 ³/₁₆ in.)
Through prior acquisition of John H. Wrenn Memorial Collection, 1991.127

As an artist accompanying a European legation to the court of the emperor Süleyman the Magnificent (r. 1520–66), Melchior Lorichs was in a unique position to survey the Ottoman capital, Constantinople. From 1555 to 1559, he made several drawings in the city, intending to disseminate his compositions in the form of woodcuts and engravings upon his return to Europe. This work is one of the most extraordinary engravings from his Turkish voyage, displaying the artist's wide-ranging interests in the diplomatic envoys, luxurious fashions, and architectural monuments of the Ottoman court.

Lorichs went to Constantinople at the command of the Holy Roman Emperor Ferdinand I, who in 1554 dispatched an entourage to settle a dispute over Siebenbürgen (present-day Transylvania), which became disputed territory after the Ottomans defeated Hungary in 1526. The artist's history of extensive travel undoubtedly qualified him for the mission.[1] Born in Flensburg, then part of Denmark, he had the benefit of a noble education and an apprenticeship with a goldsmith in Lübeck. He established his connection to the court of the Holy Roman Empire during 1547 and 1548, when he attended the Diet of Augsburg. He later traveled to Italy, where he made drawings after antique sculpture and studied contemporary artworks. Although these classical and Renaissance masterpieces were undoubtedly

location in the center of the Mediterranean, Italy represented a privileged nexus of commercial exchange. The Veneto area, in which Pisanello probably received his initial artistic training, was particularly receptive to influences from the East, partly because of its proximity to the Byzantine Empire and the long-established role that Venice played in trade and military campaigns. A gradual assimilation of Asiatic culture was also fostered by an increasing number of pilgrimages and voyages of exploration, and by the growing presence in Venice of a permanently settled community of immigrants from the East.[4] Thus, exotic artifacts, costumes, and physiognomies can be seen in Italian paintings and frescoes from the beginning of the fourteenth century.[5] The arrival of the sumptuous and enormous delegation to the Council of Florence—nearly eight hundred attended— stimulated the reintroduction of Eastern elements to

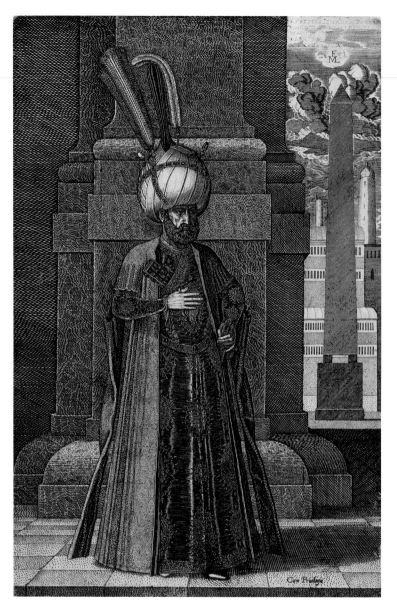

grandeur of Ottoman architecture. The artist's fascination with the ambassador resulted in another portrait, a large head study also in the Art Institute's collection.³ Together, these engravings celebrate the internationalism of a Turkish court that drew both European artists and Persian emissaries.

SHALINI LE GALL

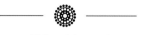

### Shiva Nataraja

10th/11th century
Southern India, Chola dynasty (c. 860–1279)
Bronze; h. 69.4 cm (27 ³/₈ in.)
Kate S. Buckingham Endowment, 1965.1130

The movement of ships carrying merchants, pilgrims, and travelers among the ports of the Indian Ocean formed a counterpart to the Silk Road of inner Asia. Traffic flowed regularly from Africa to the Middle East and East Asia—and back again—based on the yearly monsoon winds. The Chola Empire in southern India (in the present-day state of Tamil Nadu) benefited greatly from its prominent position at the midpoint of these maritime routes. Chola leaders were outward looking, conquering Sri Lanka and establishing diplomatic relations with Cambodia, China, and Malaysia. They also brought an important assertion of unity to South India for the first time through a remarkable commitment to the patronage of Hindu temples, cementing the prominence of Hinduism in South Asia.

Bronze images of Shiva Nataraja, widespread in Indian art, were first commissioned by Chola patrons for Hindu temples.¹ While stone sculptures of Hindu deities adorned the walls of religious complexes and served as the main icons inside the sanctum sanctorum, portable bronze versions enabled worshippers to take the divine presence beyond temple confines. Then, as now, the Hindu faithful could experience *darshan*—a dynamic act of seeing in which deities impart their grace to the viewer—as images of the gods were paraded on litters or chariots through the streets of the town. During these inspired moments, the gods were at their most accessible to devotees. Even today, pilgrims journey to historic Chola temples in

impressive, nothing affected him more deeply than the splendors of the Ottoman Empire.

Lorichs recognized Constantinople's significance as a city where East met West. His focus on intricately woven fabrics in this portrait of Ismael, the Persian ambassador, signals the importance of the trade that brought luxurious silks into Europe. Ismael served Shah Tahmasp of the Persian Safavid court, a ruler so enamored with textiles that he reportedly changed his clothing up to fifty times daily.² Lorichs positioned the stately diplomat in front of a monumental column that is echoed by an obelisk, using bold, crisp lines and subtle shadows to convey the

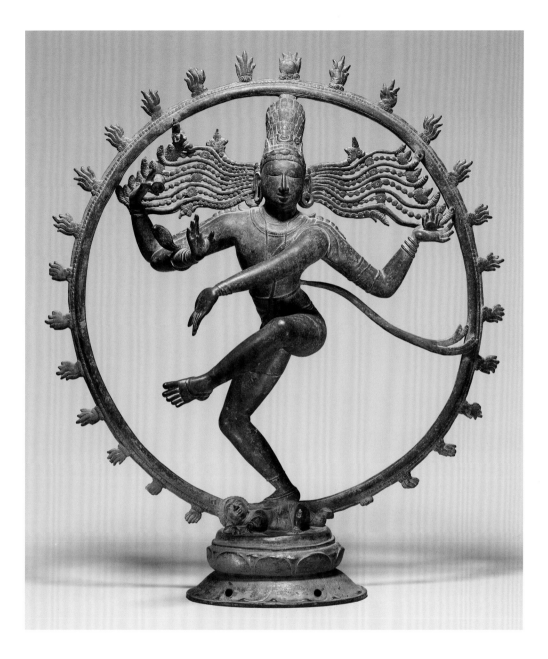

Southern India to pay homage to Shiva, just as they travel to his abode at Mount Kailash in the Himalayas.

Within the pantheon of Hindu deities, Shiva is regarded as both a destroyer and as a regenerator who represents the cyclical nature of time. His depiction as Nataraja (meaning "Lord of Dance" in Sanskrit) is a physical embodiment of this quintessential role, and his movement sets the rhythm of the universe. His precisely defined stance captures a current of motion but also adheres to the strict requirements of religious iconography. In his upper pair of arms, he balances a flame of destruction and the *damaru* (a drum) that summons life. With the lower, he performs symbolic gestures; the upturned hand assures believers not to fear, while the other points downward toward the raised foot, signifying the liberation in dance and the release of enlightenment. Shiva's right foot, planted on the back of a demon-dwarf (*apasmara purusha*), stamps out ignorance. Framing the supple movement of his dance is a wheel of flame, a constant reminder of the cosmic cycle.[2]

TANYA TREPTOW

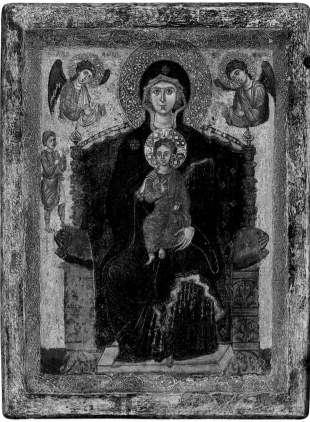
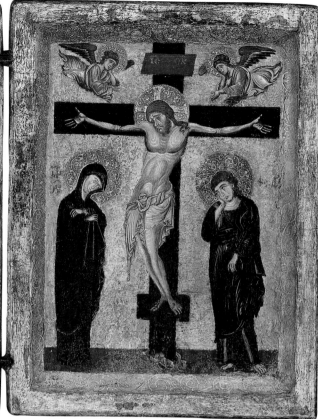

---
✿
---

*Virgin and Child Enthroned with the Archangels*
*Raphael and Gabriel*
*Christ on the Cross between the Virgin and*
*Saint John the Evangelist*
1275/85
Latin Kingdom of Jerusalem (1099–1291)
Tempera and gold leaf on panel; left wing: 38 x 29.5 cm (14 ¹⁵/₁₆ x
11 ⁵/₈ in.); right wing: 38 x 29.5 cm (14 ¹⁵/₁₆ x 11 ⁵/₈ in.)
Mr. and Mrs. Martin A. Ryerson Collection, 1933.1035

Pope Urban II launched the First Crusade in 1095, asking European powers to retake the Holy Land from Muslim rulers. This call to arms was, in part, a response to the Byzantine emperor Alexius I's plea for help against the Seljuq armies, who were expanding their territory into Anatolia (part of present-day Turkey). European Crusaders captured the city of Jerusalem in 1099, instituting the Latin Kingdom of Jerusalem and the Crusader States, which were reinforced by successive campaigns of European rulers, knights, and even peasants over the next two centuries.[1]

Surely intended for private devotion, this relatively small, portable painting was likely created in an atelier in the port city of Acre, located at the northern edge of Haifa Bay.[2] Following the decisive Muslim reconquest of Jerusalem in 1244, Acre became the capital and cultural center of the Latin Kingdom, a status it held until its own fall to the Muslims in 1291. The work's Italo-Byzantine style and its combined Greek and Latin inscriptions underscore the hybrid nature of this and other Crusader art—which combines Byzantine, Italian, French, and English styles—and highlight the complex social and cultural exchanges between Europe and the Eastern Mediterranean during the period.[3] Indeed, works such as this one participated in what scholars have more broadly defined as a "culture of shared objects," one in which the borders between artistic styles were just as fluid as the borders between peoples.[4]

In style and technique, this diptych is very similar to illuminated manuscripts produced in Acre, notably the Arsenal Bible (1250/54; Bibliothèque de l'Arsenal, Paris) and the Perugia Missal (1250/75; Museo Capitolare di San Lorenzo, Perugia).[5] For example, the gilt-plaster relief

decoration of the halos and frames, called *pastiglia*, is found on icons usually attributed to Acre painters held in the Monastery of Saint Catherine in the Sinai.[6] Likewise, the diptych's distinctly Italianate details, such as the Virgin's red snood, or head cloth, and the face of the crucified Christ, suggest that it was executed either by an Italian-trained artist active in Acre or by a painter working in Italy who had received his instruction in Acre.[7] In either case, it captures the artistic cross-fertilization of the Latin Kingdom, where painters of Western and Eastern origins practiced their craft in close proximity.

The work possesses a religious iconography that is no less hybrid. The left wing features an imposing, victorious Virgin *Nikopeia* who is venerated by a small donor figure, also in the Byzantine style. The elegant, swayed figure of Christ on the right wing, meanwhile, resembles the type of suffering *Christus patiens* that appears in the work of Giunta Pisano, the master who dominated the Pisan school in the second quarter of the thirteenth century and seems to have exerted considerable influence on Acre's artistic community.[8]

LARRY J. FEINBERG AND
CHRISTINA M. NIELSEN

### Portrait of Kōbō Daishi (Kūkai)

14th century
Japan, Kamakura (1185–1333) or
Nambokucho period (1336–1392)
Hanging scroll; ink, colors, and gold on silk
129.7 x 116.8 cm (51 ⅛ x 46 in.) without mount
Gift of Robert Allerton, 1960.40

Kūkai (744–835) was an enormously influential religious leader who was responsible for introducing Shingon (True Word) Buddhism, a form of Esoteric Buddhism, to Japan in the ninth century. He traveled to Chang'an, the capital of Tang China, to receive the teachings of the Shingon patriarch and was entrusted as the religion's next leader. Upon his return, a monastery was built on Mount Koya

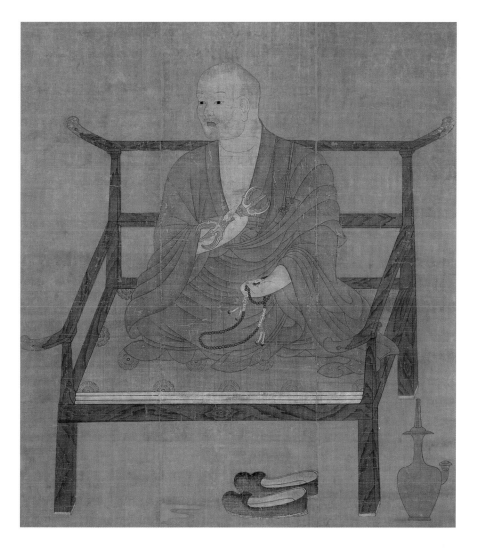

outside of Kyoto; constructed with imperial support, it functioned as the sect's new headquarters. After his death, Kūkai received the name Kōbō Daishi (Great Teacher of the Divine Law) and was revered as a saint.

Kūkai is shown here as a mature priest. In his right hand he holds a *vajra* that represents the indestructible force of the true religion; in his left, he clutches a Buddhist rosary. His shoes are laid out neatly in front of his chair, and off to the side is a jar used in rituals. Portraits of Kūkai of this type follow a particular lineage: each has been copied from another, based initially on a few key models. When creating a new portrait of a religious figure, the face is the most important feature, as it bears the likeness of the individual. Therefore, it is this portion of the figure that is copied the most carefully and given the most detailed treatment. In particular, the bumpy shape of the head and the peaceful expression seen here denote Kūkai as a man of great spirituality.

Although Buddhism had been introduced to Japan from Korea in the sixth century, the arrival of Esoteric Buddhism cemented imperial sponsorship of the faith and forever changed the country's religious landscape. Shingon promised that through effort, ordinary individuals could achieve enlightenment during this lifetime, a belief at the center of many later Buddhist sects in Japan. However, Shingon ritual artwork is rich in symbolism and iconography that is known only to the initiated, a fact that only served to fuel interest in the sect among the aristocracy. Rituals and chants, when used properly, were thought to be effective ways to protect the nation and even pray for rain.

In addition to being a religious leader, Kūkai was also considered one of the most literate men of his age. He wrote a number of religious treatises, compiled Japan's first known dictionary, and is said to be the inventor of the kana alphabet, still in use today.

JANICE KATZ

## *European Banquet Scene*

c. 1600

India, Mughal dynasty (1526–1857)

Opaque watercolor and gold on paper; painting: 18.5 x 14.2 cm (7 ¼ x 5 ⅝ in.); page: 42.5 x 29.2 cm (16 ¾ x 11 ½ in.)

Lucy Maud Buckingham Collection, 1919.891

In both its style and content, this image is a product of cultural exchange between two political forces on the Indian subcontinent: the powerful Mughal Empire in the north and the Portuguese colony in Goa, a port city on the southwest coast.[1] Painters for the third Mughal emperor, Akbar (r. 1556–1605), were actively encouraged to emulate the European images that began to circulate at his court around 1565.[2] Yet rather than copying them slavishly, they worked them into pastiches that were derived from a number of sources. In particular, Akbar's atelier incorporated the European innovations of perspective, modeling, naturalism, and psychological expression into Mughal painting. Another visual hallmark of this school is the use of elaborate architectural settings that give the appearance of stage sets rather than natural backdrops, as in this scene.

Akbar was unusually ecumenical in matters of philosophy, religion, and the arts.[3] For instance, although he was a Muslim, he married the Hindu daughter of the Raja of Amber. Moreover, he convened interfaith debates

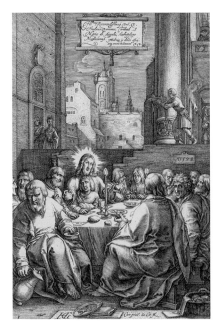

FIGURE 1. Hendrik Goltzius (Dutch, 1558–1617). *The Last Supper*, from *The Passion of Christ*, a series of twelve engravings, bound in leather; 20.2 x 13.4 cm (7 ¹⁵/₁₆ x 5 ⁵/₁₆ in.). Purchased from Robert M. Light, Inc., Joseph B. Fair Fund income, 1975.140.1.

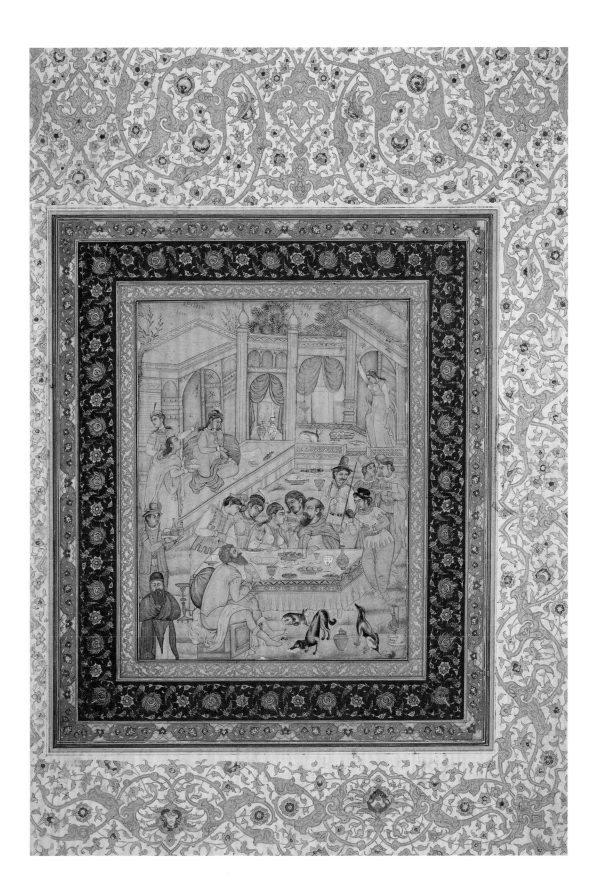

at the royal palaces, events that came to include not only Sunni and Sufi Muslims but also Shiite Muslims, Christians, and Hindu Brahmins, among others. In 1580 the first group of Jesuit missionaries arrived from Goa; taking part in these great colloquia, they presented to the emperor seven volumes of the Antwerp Polyglot Bible (1571–80), complete with text in Chaldean, Greek, Hebrew, and Latin as well as title pages engraved with images by Flemish artists. The missionaries also brought two European altarpieces that greatly impressed the emperor and his court.[4]

The Jesuits viewed the visual arts as a powerful communicative aid in their missionary pursuits. In India, as in other parts of Asia, images helped them to surmount language barriers. They prepared collections of engravings for their voyages, since these were much more easily portable than paintings and sculptures. Most of the prints that circulated at the Mughal court were from northern Europe, particularly Antwerp, the main port from which ships sailed to Goa. An image of the Last Supper by Hendrik Goltzius in the Art Institute's collection (fig. 1) is just the kind of print that might have inspired the Indian painter who produced this banquet scene, complete with a European man holding a rosary and a figure seated opposite him, where we would expect to find the apostle Judas.

<div align="right">CHRISTINA M. NIELSEN</div>

## Crossroads

1997
Art Spiegelman (American, born Sweden 1948)
Lithograph on off-white wove paper; 77.6 x 58.5 cm (30 ½ x 23 in.)
Stanley Field Endowment, 1997.662

Since their forced expulsion from Palestine in the sixth century B.C., Jews have founded new communities in many foreign lands. In Europe, Jewish religious and secular life flourished for centuries, until it was all but obliterated during the Holocaust, when between 1933 and 1945 approximately six million Jews were systematically exterminated. Those who survived the atrocities settled where they could and attempted to rebuild their shattered lives.

Art Spiegelman's parents survived the Holocaust. In his critically acclaimed *Maus: A Survivor's Tale* (1986), Spiegelman created a graphic novel about his family's encounter with the Nazis.[1] In response to Hitler's declaration that Jews were not of the human race, all the characters in Spiegelman's story take the form of animals: Jews are mice, Nazis are cats, Poles are pigs, and Americans are dogs. His use of the comic strip format to tell his story helped elevate cartoons to a high art form.

In *Crossroads*, Spiegelman explored the theme of Jewish migration using the cartoon format and the same iconographic device: all the Jews—except Jesus—have mouse faces. The print is composed of three pictorially distinct yet thematically related scenes that can be read as a narrative. The image at upper left, depicting an older, bearded mouse standing before the crucified Christ, is based on a print by the prolific nineteenth-century French artist Gustave Doré. It represents the Christian folktale of the Wandering Jew, in which Jesus, mocked by a Jewish cobbler on the way to the Crucifixion, condemns him to roam the earth until the Second Coming. In the center of Spiegelman's composition, the mouse couple, wearing Stars of David on their coats, represents the artist's parents at the junction of two roads that take the form of a swastika in a barren setting. Below, Spiegelman and his children hail a taxi in New York City.

Reading from top to bottom, the story follows a temporal progression, beginning with the ancient curse, continuing with the displacement of the Jewish couple by the Nazis, and ending with the imminent cab ride of the artist and his family. A multilayered narrative emerges: the mythological, divinely enforced expulsion of the individual; the twentieth-century, historical, and politically motivated exile of the couple; and the contemporary, voluntary movement of the family in their new homeland. The swastika-cum-crossroads at the center of the composition unites the three pictorial elements, reinforcing the theme of cyclic banishment, peregrination, and resettlement.

<div align="right">RAY HERNÁNDEZ-DURÁN</div>

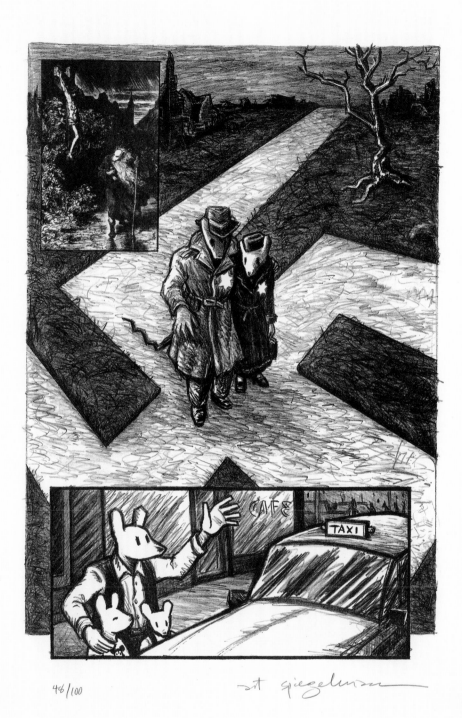

46/100     art spiegelman

# Trade

Amention of the historical Silk Road often evokes images of the itinerant traders who led caravans of beasts, laden with raw goods and finished products, along the thousands of miles of overland routes between Europe and Asia. The objects featured in this section, however, were selected to conjure up visions of an even broader range of merchants and their wares, including late-fourteenth-century horsemen who carried gold and ivory across the Sahara Desert (see p. 52) and early-nineteenth-century Americans who sent their ships from the Eastern Seaboard to Asia, dealing in the porcelain, silks, and tea of the China Trade (see p. 68).

Some of the works showcased here, like the jeweled mirror frame from Mughal India (p. 53), impress us for the way in which their makers combined costly materials culled from around the world. Others, like the Aesthetic Movement serving table (p. 54), which consists of wood panels carved in Ahmedabad and assembled in New York City, are remarkable because of their unexpectedly cosmopolitan materials or means of manufacture—or because, like the Swahili chair from East Africa (p. 55), their unique design represents a fusion of styles resulting from cross-cultural trade.

The objects in this section also suggest how channels of commerce operated as conduits for the transmission of artistic technologies and styles. Sericulture, for example, which originated in China and remained a closely guarded secret there for millennia, eventually spread to Japan and later traveled as far west as the Iberian Peninsula. There and in cities including Bursa, in present-day Turkey, highly skilled weavers produced opulent silks like the Art Institute's brocade and velvet panel (p. 63), with its stylized floral decoration. European consumers, in turn,

eagerly purchased these richly patterned Islamic textiles and invested them with a range of new meanings both in everyday life and in artworks such as *Saints John the Baptist and Catherine of Alexandria* (p. 59). An even more complex process of movement and borrowing took place with blue-and-white ceramics. Early Chinese examples like the Art Institute's dish (p. 66) were influenced by the form and decoration of Persian vessels and were probably intended for export to the Near East. Once there, these wares inspired imitations of their own, including an extraordinary fritware tankard (p. 62) that resulted from Turkish artists' attempts to equal the refinement of Chinese porcelain.

The elegant blue tulips on this tankard, together with those on the Bursa velvet and the red-and-white one depicted in a still life by the Dutch painters Adriaen van der Spelt and Frans van Mieris (opposite and p. 64), are emblematic of the ways in which trade objects, in this case a rare flower, move through and between cultures over time, sometimes becoming recurring decorative motifs in their own right. The tulip made its way to the Netherlands—it remains an important commodity there to this day—from the Ottoman Empire, where it had been cultivated as early as the year 1000. It was not a native bloom, though; it was actually imported to Turkey from Persia and is thought to have originated in the Tian Shan and Pamir Alai mountain ranges in Central Asia, spreading east to China and Mongolia, and west to Azerbaijan and Armenia. So broad was the distribution of goods and knowledge, however, that Ottoman—and, ultimately, Dutch—artists came to treasure these flowers and incorporate images of them into their works, many of which were themselves made with materials and techniques imported from abroad.

Opposite: Detail of *Trompe l'Oeil Still Life with a Flower Garland and a Curtain* (p. 64).

### Equestrian and Four Figures
Probably late 14th/eary 15th century
Bankoni
Bougouni region, Mali
Terracotta; equestrian: 70 x 21 x 48.5 cm (27 ½ x 8 ¼ x 19 ⅛ in.);
other figures: h. 46 cm (18 ⅛ in.) max.
Ada Turnbull Hertle Endowment, 1987.314.1–.5

For close to a millennium, merchants have traveled across the formidable Sahara Desert, relaying goods and ideas between West and North Africa as well as to and from the wider Mediterranean world, the Middle East, and even Asia.[1] From the twelfth through the sixteenth century, the Kingdom of Mali, a powerful empire that extended across a vast, culturally and religiously diverse portion of northern West Africa, largely controlled trade at the desert's southern edge.[2] The kingdom oversaw the flow of valuables, including gold, ivory, and slaves, northward in exchange for salt and luxury goods such as brass, glass, glazed pottery, paper, spices, and semiprecious stones.[3] At its height in the fourteenth century, its realm encompassed Timbuktu and Gao, great centers of commerce and Islamic learning on the upper curve of the Niger River, and the major commercial hub of Jenné-jeno, located southwestward on the river's inland delta. So great was the empire's wealth that its ruler, Mansa Musa, is prominently depicted holding a large chunk of gold in the Catalan Atlas (1375; Bibliothèque Nationale de France, Paris), in which he is described as "the richest and most distinguished ruler of this whole region."[4]

Warriors mounted on horseback patrolled Mali's borders, and they are frequently portrayed in terracotta sculptures from the epoch. This large, fluidly modeled horseman and four seated individuals come from a region that in the present-day nation of Mali stretches from Segu to Bougouni. Sculptures in this style are called Bankoni, named for a village near the country's capital city, Bamako, where archaeologists excavated a stylistically similar terracotta figure and several fragments.[5]

Although little is known about the context in which such objects were used, their rich details of dress and embellishment evoke wealth and high status, creating a vivid picture of the warriors and merchants who wielded power.[6] Each figure wears an elaborate hairstyle and regalia that includes necklaces and oversized, circular bracelets. Mounted on his bridled horse, the bearded warrior towers over the other figures. A sheathed knife is attached to his upper left arm, and at his waist he wears a belt with attached pendants, possibly brass bells or cowrie shells imported from the Indian Ocean. To this day, equestrian images continue to signify power and elite status across this region.

KATHLEEN BICKFORD BERZOCK

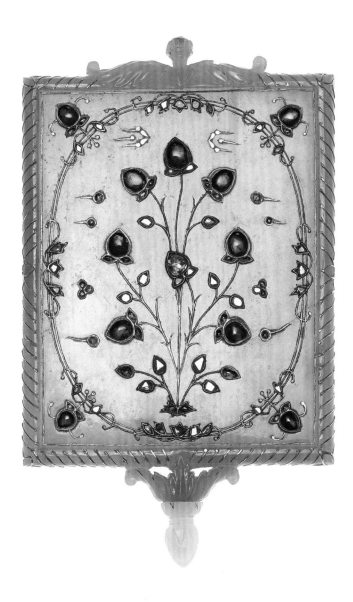

### Mirror Frame
17th/18th century
India, Mughal dynasty (1526–1857)
Nephrite jade (pale green), inlaid with gold in the *kundan* technique and set with rubies, emeralds, and diamonds
16.4 x 10.2 x 1 cm (6 7/16 x 4 x 3/8 in.)
Gift of Mr. and Mrs. Chester D. Tripp, 1970.474

This gem-studded mirror frame is a fine example of the luxury arts that were created in abundance for the court of the Mughal emperors, an Islamic dynasty that controlled a large section of the Indian subcontinent from the sixteenth to the nineteenth century. Gently curving stems of inlaid gold wire sprout into flower buds made of diamonds, emeralds, and rubies. Acanthus leaves and additional buds echo this design on the finely carved handles at the top and bottom.

The Mughals ruled over an empire rich in natural resources, most notably spices, that filled their coffers and allowed them to indulge their aesthetic whims. Visitors from abroad marveled at the magnificence of the court; one observer, the seventeenth-century English ambassador Thomas Roe, noted of the emperor Jahangir (r. 1605–27), "In jewells (which is one of his felicityes) hee is the treasury of the world."[1] To a great extent, this was true: for opulent

objects such as this, the Mughals drew upon their own diamond mines at Golconda in south central India, which remained the most significant source for this highly prized gemstone until the eighteenth century, when other mines were discovered in Brazil. The Mughals acquired other precious and semiprecious stones through trade, looking to Burma (present-day Myanmar) for rubies, Sri Lanka for sapphires, and far-off Colombia for emeralds. In order to acquire gold and silver, India traded its own highly valued commodities, including silk and cotton textiles.

The Mughals obtained their jade from the Kunlun Mountains near the Silk Road oasis city of Khotan, home to the largest deposit of nephrite in the world.[2] The first Mughal emperor, Babur, was himself born in Central Asia and counted as ancestors the warlords and empire builders Ghenghis Khan and Timur. Even after they arrived in India, the Mughals maintained strong cultural ties to the Timurid courts of Samarkand. Babur did not view himself as the founder of a new dynasty in India but rather as a ruler who had revived the Timurid Empire, although in a land that his forebear had only briefly ruled. Both Babur and his successor, Humayun, admired the great Timurid monuments in Herat and Samarkand, and they considered Timurid arts—whether large-scale architecture or finely carved jade objects—to be the epitome of cultural sophistication. Futhermore, Chaghatay Turkish was the mother tongue of the first three Mughal emperors. It was only superseded by Persian as the lingua franca of their courts in the second half of the sixteenth century, a further testament to the fluidity of people, things, and ideas across vast geographical distances.

CHRISTINA M. NIELSEN

### Serving Table

1880/90
Designed by Lockwood de Forest (American, 1850–1932)
Carved in Ahmedabad, India, and assembled in New York City
Teakwood, ash, or oak; 119.4 x 99.7 x 48.3 cm (47 x 39 x 19 in.)
Gift of Mrs. Herbert A. Vance
through the Antiquarian Society, 2003.171

Influenced by the Aesthetic Movement, Lockwood de Forest shifted his emphasis from painting to the decorative arts in the late 1870s.[1] In 1878 he joined the recently founded Society of Decorative Art in New York and by October 1880 had formed an interior design firm, Tiffany and De Forest Decorators, with Louis Comfort Tiffany. Emphasizing visual beauty for its own sake, the Aesthetic Movement also led American designers such as De Forest and Tiffany to look beyond Western forms to the art of the

Middle East, India, China, and Japan to find exciting new models for their work.

In 1880 De Forest traveled to India to buy furniture for his clients. While intending to stay for only a few months, he grew fascinated with traditional woodcarving and became devoted to the Indian craft revival, which sought to preserve indigenous artistic traditions endangered by mass-produced imports from the West. Seeking to interest Americans in the movement, De Forest published *Indian Architecture and Ornament*, a book of photographs surveying the most important monuments of traditional Indian architecture. He concluded in his introduction, "I can only hope that I have been able to stimulate in some, at least, the desire to know more of this wonderful Oriental art which is so rapidly disappearing."[2]

De Forest spent a year establishing a wood and metal workshop in Ahmedabad, both to promote local crafts and supply his business. Back in New York in 1881, he founded his own independent furniture and interior decorating concern. This serving table is typical of his work in its use of pierced moldings and panels that were produced in India and then applied onto a Western furniture form. Artisans in his Ahmedabad company carved wood and brass panels with a selection of designs copied from the ornament on the city's most notable architectural sites. De Forest produced drawings for each piece of furniture, and then craftspeople in Ahmedabad or New York assembled the finished product from the existing stockpile of wood and brass carvings.[3] Although more complex furniture types were created in India, taken apart for shipping, and then reassembled in New York, less ornate examples such as this one were most often made in the United States. De Forest's New York artisan would have first constructed the base frame and then covered it with Ahmedabad-carved wood, evident here on all surfaces except the top deck and bottom shelf.[4] While an easily recognizable, useful piece of furniture for a nineteenth-century American, the server thus also displays the veneer of exoticism so fashionable with Aesthetic Movement designers.

ELLEN E. ROBERTS

*Chair (Kiti Cha Enzi)*
19th century
Swahili
Probably Lamu, Kenya
Wood, ivory, bone, and string; 125.7 x 75.6 x 72.4 cm
(49 x 29 x 28 in.)
Restricted gift of Marshall Field V, 2004.476

Helped by natural harbors and seasonally shifting monsoon winds, coastal East Africans have participated in maritime trade from as early as the first century.[1] Sailing in shore-

hugging dhows or larger oceangoing ships, merchants traveled to the Persian Gulf and onward across the Arabian Sea to western India, where they connected with trade networks extending as far as Europe and China.[2] By the eleventh century, a series of prosperous port cities, among them Kilwa, Lamu, Mogadishu, Mombasa, Pemba, and Zanzibar, extended from Somalia in the north to the southern border of Tanzania. While politically independent, these urban centers were united by a shared Swahili culture and language, and by an adherence to the Muslim faith. They were ideally situated to function as entrepôts, brokering the sale of goods from the interior including gold, ivory, lumber, and slaves, which they exchanged for Egyptian glass; Indian beads and cloth; and Chinese, Indian, and Persian ceramics, among other things.[3]

In the sixteenth century, the Portuguese systematically conquered the Swahili city-states, brutally wresting control of valuable trade relationships and establishing fortresses from which to run their affairs. Many Swahili people fled. Those who remained were isolated within a new social system that looked outward for its sense of identity.[4] Portuguese authority was followed in the eighteenth century by Omani rule and in the early twentieth by British domination. With each conquering state, newly imported goods and practices took root as symbols of authority and power among the Swahili elite.[5]

This style of high-backed seat with bone and ivory inlay, known as a "chair of power" or "grandee's chair" (kiti cha enzi), is a graphic reminder of the region's complex history of international trade and conquest. Its form bears strong resemblance to sixteenth- and seventeenth-century chairs imported from Portugal and Spain, as well as to Portuguese- and Spanish-influenced examples made in India.[6] Comparisons have also been made with chairs from the Mamluk period (1250–1517) in Egypt.[7] In any case, the Swahili version is clearly the result of foreign influences that have been artfully synthesized and reshaped by local artisans. Like most kiti cha enzi in collections today, this one dates from the nineteenth century.[8] Such intricately constructed and embellished chairs were made in large, specialized workshops, including those on the island of Lamu, off the Kenyan coast, where this piece is believed to have originated. They could be found conspicuously displayed in wealthy households along the Swahili coast into the first half of the twentieth century.[9]

KATHLEEN BICKFORD BERZOCK

## Women Engaged in the Sericulture Industry (Joshoku kaiko tewaza-gusa), sheet 9

1798/1800
Kitagawa Utamaro (Japanese, c. 1756–1806)
Color woodblock print, ōban; 39.4 x 26.7 cm (15 ½ x 10 ½ in.)
Clarence Buckingham Collection, 1925.3254

Sericulture likely entered Japan from China sometime between 200 B.C. and A.D. 200, during the time of the Han dynasty. Beginning in the seventeenth century, Japan's limited trade with other nations stimulated domestic silk production, and, along with it, an interest in the process itself. In his series of prints on the subject, Kitagawa Utamaro offered a thoroughly detailed explanation of the steps involved while enticing viewers with the elegant women who perform them.

Together, the twelve sheets comprise a continuous composition from right to left, with an explanation of each stage in the scalloped clouds above the images. In the ninth print, shown here, women boil the cocoons shed by silkworms in order to extract the thread, which the figure at right is turning on a spindle. Other pictures in the series show women brushing silkworm eggs into a hatching box with a feather; feeding the larvae mulberry leaves until they spin cocoons; coaxing the newly emerged moths to lay more eggs; and later releasing them. The final scene shows silk thread being woven into a garment on a loom. All the while, the text highlights the intense labor involved in the process. For example, above the illustration of women preparing mulberry leaves for the hungry worms, it says, "This shows how busy it gets, without a moment's respite."[1]

The Art Institute has a complete edition of the series, which is considered to be the first issued with a palette limited largely to greens, purples, and yellows. Utamaro was the foremost illustrator of women in prints such as these, achieving fame in the West for his bust portraits of the famous, perfectly coiffed beauties of his day. He was a prolific artist who produced about two thousand designs for prints during his career, as well as book illustrations that are considered to be the best examples of the genre published in the Edo period (1615–1868) and several dozen paintings. Through his use of poses, facial expressions, and clothing, Utamaro brought a grace to his female figures that was markedly different from anything that came before.

JANICE KATZ

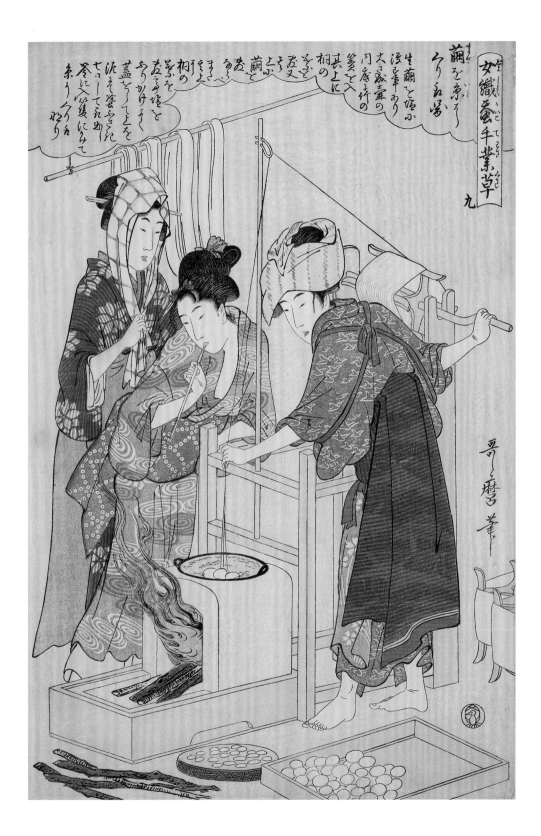

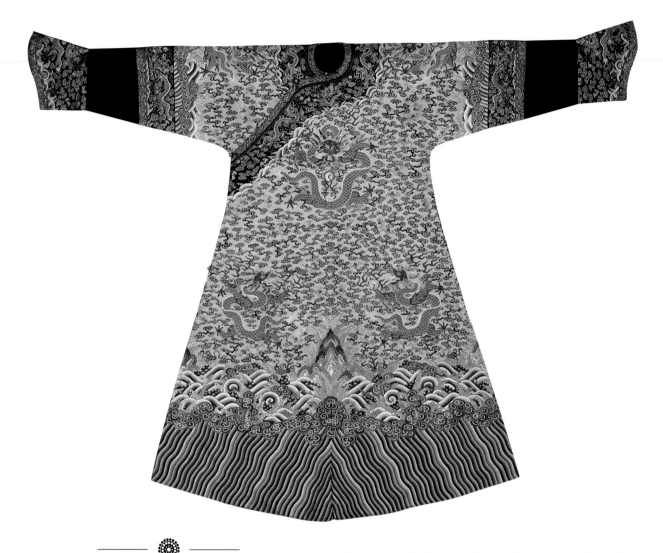

*Empress's* **Jifu** *(Semiformal Court Robe)*
Late 18th/early 19th century
China, Qing dynasty (1644–1911)
Silk and gold-leaf-over-lacquered-paper-strip-wrapped silk, slit and
dovetailed tapestry weave with interlaced outlining wefts; painted
details; trimmed with cords of gilt-metal-strip-wrapped silk couched
with silk; sleeves: silk, warp-float faced 7:1 satin weave self-patterned
by areas of plain weave; edging and closures: silk and gold-leaf-over-
lacquered-paper-strip-wrapped silk, warp-float faced 5:1 satin weave
with weft-float faced 1:2 'z' twill interlacings of secondary binding
warps and supplementary patterning wefts; lined with silk, 4:1 satin
damask weave; cuffs lined with silk, 4:1 satin weave; metal buttons
146.3 x 195.2 cm (57 ⅞ x 76 ¾ in.)
Gift of Mrs. Clayton W. Miller, 1946.459

For thousands of years, silk played an essential role in China's
domestic and foreign affairs, easily recognizable as a sign of
power, social status, and wealth. It was also employed in
religious rituals, and gifts of silk were powerful diplomatic
tools. A major focus of economic exchange between East
and West, it was even viewed as a hard currency and could
be used to pay taxes.[1] Regular commerce in silk can be
traced back to the Han dynasty (206 B.C.–A.D. 220), when
Emperor Wudi dispatched his envoy Zhang Qian to
Central Asia to seek allies against invaders from the north.
Through contact with Central Asia, distant lands such as
Persia and even the Roman Empire came to prize Chinese
goods, particularly silk. Overland Silk Road trade peaked
during the Tang dynasty (618–907), whose rulers were
open to new ideas and technologies. Silk industries—more

or less dependent on Chinese raw materials and methods—took root in Sogdiana (including Samarkand, in modern Uzbekistan), Sasanian Iran, and Byzantium.

The Chinese court had maintained a monopoly on the manufacture of silk for export until sometime in the middle of the first millennium. Stories abound of imperial brides spiriting silkworms, mulberry leaves, and a knowledge of sericulture to their new homes in Central Asia, as do legends of Byzantine monks, among others, hiding silkworms in walking sticks.[2] All of these tales suggest just how jealously the Chinese court guarded its trade secret and how desperately foreigners wanted to share in the glory.

Within the highly ritualized milieu of the Chinese court during the Qing dynasty, textiles were charged with great political and spiritual significance. Court regulation focused on the color and iconography of garments in order to signal distinctions of rank and entitlement. Yet more than being merely a marker of identity, such attire followed Confucian ideals that viewed appropriate apparel as being crucial to virtuous conduct and, even more, to the success of specific events.[3] This impressive, semiformal robe is of a type known as *jifu* (auspicious clothing), worn at audiences with the emperor when affairs of state were determined. Qing garments such as this one were also the products of careful aesthetic and cultural blending. The no-madic Manchu, who conquered China and founded the Qing dynasty in 1644, used court fashions to at once proclaim their ethnic difference from their Han subjects and justify their right to rule, fusing their own styles with native Chinese symbols and design elements.

CHRISTINA M. NIELSEN

## Saints John the Baptist and Catherine of Alexandria

c. 1350

Workshop of Paolo Veneziano (Italian, act. 1333–58/62)
Tempera and gold on panel; 77 x 49.7 cm (30 ¼ x 19 ⅝ in.)
Charles H. and Mary F. S. Worcester Collection, 1947.116

During the Middle Ages and Renaissance, Venice's position at the center of an extensive commercial empire ensured the flow of precious materials and art objects to its door. Many

of these, including luxury ceramics, glass, metalwork, and silk textiles, came from trading centers in the eastern Mediterranean and beyond, among them Alexandria, Damascus, Delhi, Samarkand, and Tabriz.[1]

As this work suggests, one of the most substantial influences on early Venetian painting—and on the city's visual and architectural heritage more broadly—came from its longtime trading partner, the Byzantine Empire. While the rich color, lavish use of gold, and tall, sinuous figures recall the rarified elegance of Byzantine art, the piece also reveals how Eastern styles were redeployed in Venetian settings. Paolo Veneziano, the master whose atelier produced this picture, popularized the composite altarpiece, a collection of painted scenes and figures set within a richly carved and gilt frame, as the premier decorative feature of the city's churches. In so doing, he effectively recast the remote, immense mosaic figures that had adorned the upper part of Byzantine churches into a new medium, scale, and location. Its original viewers would have experienced this panel as a central element of such an altarpiece, brightly colored and glittering amidst its dim surroundings.[2]

A similar process of adaptation is revealed in the painting's most resplendent detail, Saint Catherine's robe. During and after the Crusades, Italians became intensely interested in wearing, collecting, and imitating the many sumptuous Islamic and Asian textiles they obtained through both commerce and conquest. Such fabrics often appear in works such as this, where they were used to signal their holy wearers' elite status and Eastern origins. Here,

the motif that appears on the saint's garment, in which split palmettes spring from thin stems decorated with filigree work, ultimately derives from Chinese sources. A fragment of a similar silk textile from Mamluk Egypt (fig. 1), now in the Art Institute, likewise reveals the influence of East Asian designs, which moved quickly along trade routes from Central Asia through Persia into Syria and Egypt.

More fascinating yet is the band of imitation Arabic calligraphy that appears on Saint Catherine's bodice; this was inspired by the Italians' familiarity with *tiraz* fabrics, which were adorned with honorific inscriptions.[3] Throughout the Islamic world, rulers presented these garments, which incorporated gold and silver threads, to high-ranking individuals as a sign of preferment. Unfamiliar with these customs and with Arabic, later Italians mistakenly associated the language and the textiles with their perceived place of origin—the Holy Land—and used them to express their reverence for the Eastern roots of Christianity.

GREGORY NOSAN

## Fragment
15th century
Spain, Andalucia
Silk and gilt-metal-strip-wrapped silk, warp-float faced 4:1 satin weave with plain interlacings of secondary binding warps and patterning wefts; 45.5 x 10.3 cm (17 7/8 x 4 1/8 in.)
Restricted gift of Mrs. Chauncey B. Borland, 1951.253

This luxurious silk fragment represents the enduring legacy of medieval Spain's Muslim traders and craftsmen, as well as countless others who worked or traveled along the land and sea routes connecting East and West. Sericulture (the raising of silkworms) and the making of silk were trade secrets that the Chinese closely guarded until the middle of the first millennium. At that time, production centers began to spring up in Central Asia and further west, just as Islam was spreading east and west from the Arabian Peninsula.[1] Indeed, Muslim merchants, bound together in transnational fellowship, were important agents in importing sericulture to the Middle East. From there, artisans took this technology to

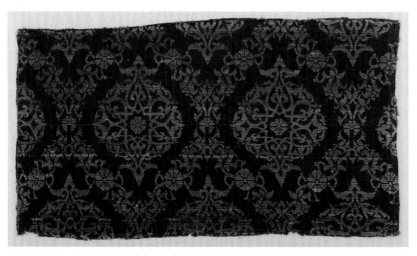

FIGURE 1. *Fragment.* Egypt, Mamluk period, 14th/15th century. Silk, warp-float faced 4:1 satin weave with supplementary patterning wefts bound by secondary binding warps in plain interlacings; 20.8 x 38.2 cm (8 1/4 x 15 in.). Grace R. Smith Textile Endowment, 1982.1461.

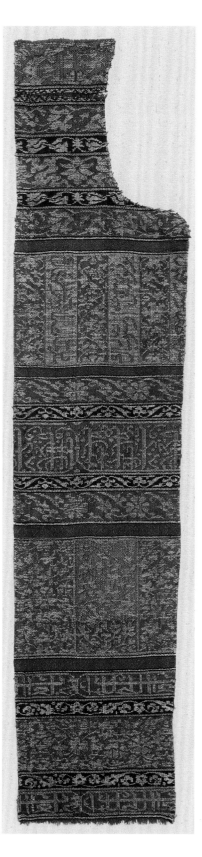

Al-Andalus, the portion of the Iberian Peninsula under Muslim rule, making southern Spain the first site of silk production in Europe. In time, silk became a major export for the Islamic kingdoms of Spain, so much so that they dominated the western Mediterranean markets in the eleventh and twelfth century.[2] Even so, they could not keep up with demand and depended on trade to secure essential materials such as extra raw silk from Persia, which held a monopoly on the export of Chinese silk for centuries, and Cyprus, the source of the best gold threads for weaving.[3]

The refined silks produced in Al-Andalus and the later Nasrid Kingdom, which was based in Granada (1230–1492), were also coveted by Christians in the north of the Iberian Peninsula. Kings and bishops acquired textiles such as this through direct commerce, as diplomatic gifts, and as trophies and spoils of war.[4] Surprisingly enough, a large number of silks, as well as other luxury goods from Islamic Spain, including carved ivory caskets, have been preserved through the centuries in Spanish ecclesiastical treasuries.[5] In addition to being used as hangings and vestments in religious ceremonies, Islamic silks were employed as wrappings for saintly relics and burial shrouds for Christian royalty.

The appearance of obviously Islamic art in Christian churches has been interpreted by scholars as a sign of Christian victories in the reconquest of Spain from Muslim rulership.[6] In more recent centuries, many fragments have made yet another transition, out of churches and beyond Spain itself, onto the international art market. This one, with its bands of scrolling foliage and calligraphic text, was purchased from the well-known Armenian dealer Dikran G. Kelekian, who maintained offices in Cairo, New York, and Paris.

Christina M. Nielsen

———— ✸ ————

## Tankard

1575/1600
Turkey, Iznik
Fritware painted in underglaze blue, turquoise, red, green, and black; h. 19.6 cm (7 ¾ in.)
Mary Jane Gunsaulus Collection, 1913.342

This charming tankard, fired in the famous kilns of Iznik, south of Istanbul, is an example of the extraordinary creative innovations achieved by artists of the Ottoman Empire during the sixteenth century. The lyrical sway of roses, tulips, and hyacinths explores the patterns of nature,

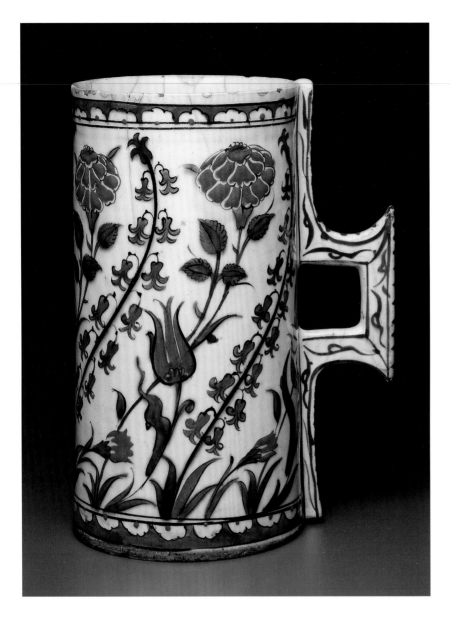

in the narrow, scalloped bands along the tankard's lip and base, which are derived from Chinese cloud motifs. Although the loose floral patterns also originated in blue-and-white ceramics, the decoration of Iznik pottery reflected local traditions as well, and the flower types were inspired by a long history of garden cultivation in the Middle East.[2]

In Islamic culture, poets often compared flowers to the features of a loved one, frequently describing paradise itself as a garden. Capturing this metaphorical significance and evoking the simple tranquility of an outdoor setting, this tankard reflects the Ottoman fascination with flowers and gardens.[3] In fact, there was an actual craze for tulips that not only permeated the Islamic world but infected Europe as well. The plants were introduced to Holland from Istanbul, inspiring "tulipmania." In the 1630s, bulbs were bought and sold for record prices, creating a speculative frenzy with fierce competition for the production of new colors and varieties.[4] Clearly, these goods were not casually transmitted between traders but rather became the focus of a major cultural interchange. Eventually, the bottom fell out of the tulip market in Europe, but in the early eighteenth century, the flower once again so dominated Ottoman court culture that the years between 1718 and 1730 are known as Lale Devri, or the Tulip Period.

a common motif in art of the Islamic world. However, the large, unfurling blooms are clearly different from the controlled, arabesque foliage popular in the work of earlier centuries. Bright hues of black, blue, green, and orange-red, set against a viscous white background, reflect a mastery of glazing technique that characterized the Iznik workshops.

The sudden emergence of these innovations can best be explained as a reaction to the growing dominance of blue-and-white porcelains from Yuan and Ming China, which were imported into Turkey during this period. The Iznik style grew out of the Ottoman court's attempts to match the refinement of Chinese wares.[1] This influence is visible

Like tulips, Ottoman ceramics also became popular in Europe. During the sixteenth century, Iznik pottery was exported throughout the Ottoman Empire and to England, Germany, and Italy, where it influenced maiolica potters in Genoa and Venice.

TANYA TREPTOW

## *Panel*

Late 16th/early 17th century
Turkey, Bursa
Silk, cotton, and gilt-metal-wrapped silk, warp-float faced
4:1 satin weave with supplementary brocading wefts,
supplementary binding wefts, and supplementary pile warps
forming cut voided velvet; 138.3 x 66.1 cm (54 3/8 x 26 in.)
Gift of Burton Y. Berry, 1954.91

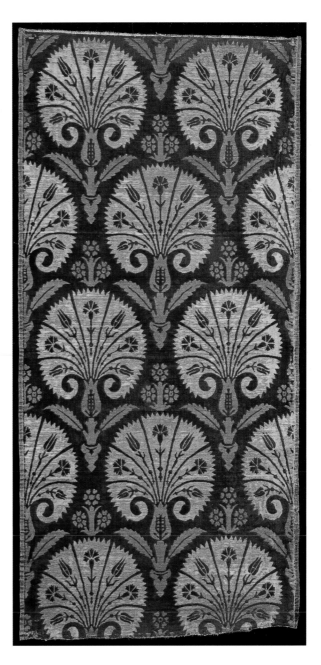

The appetite for luxury textiles at the Ottoman court was insatiable. Weavers were kept busy producing great lengths of yardage such as this, which were used for a wide range of objects, from imperial caftans to floor coverings.[1] Official promotions were marked by the presentation of lavish garments or lengths of silk, and robes of honor were given to visiting dignitaries. For this reason, the imperial treasury stockpiled enormous quantities of rich fabric. The spectacle of the Ottoman court, with the glitter of ceremonial dress and the variety of costume details, dazzled even the most cosmopolitan of visitors (see pp. 41–42).

This velvet was produced in Bursa, a major city located on the westernmost end of the Silk Road in Anatolia (part of present-day Turkey). The capital of the Ottoman Empire from 1326 to 1365, it enjoyed fabulous wealth from the revenue generated in its silk markets. Because Bursa was the main entrepôt for textiles from Egypt, Iran, and Syria, all silk passing through Ottoman territory was weighed on the city's scales. Fabrics were then taxed according to their country of origin, quality, and weight. Despite these tariffs, ties to the Italian textile industry were very strong during the fifteenth century, when woven silks from Florence and Lucca had a visible impact on Ottoman designs.[2] But by 1500, Italian wares were being eclipsed by those of native artisans.[3] This led to stylistic borrowing on a grand scale, so much so that it is sometimes difficult to discern the exact location of origin for a given textile. Indeed, Anatolian flora, like that in this fragment's repeating pattern of artichoke leaves, carnations, and tulips, even appears on some Italian silks from the period. International traffic in various raw materials was essential to Ottoman textile production. By the middle of the sixteenth century, for example, the Turks were trading with the Spanish and Italians for cochineal, a popular red dye made from a Mexican insect.[4]

As suggested above, Bursa retained its preeminence as the silk-weaving center of the Ottoman Empire long after the capital moved to Istanbul. For example, in 1530

Ibrahim Pasha, the favorite vizier of Emperor Süleyman the Magnificent (r. 1520–66), left specific orders for a group of elite foreign craftsmen—Bosnians, Circassians, Hungarians, and Italians, among others—to receive apprenticeships in Bursa. Few Bursa silks remain in Turkey today. A large number were used as liturgical vestments in the West and were therefore preserved in European church treasuries, only finding their way to private and museum collections at around the turn of the twentieth century.

CHRISTINA M. NIELSEN

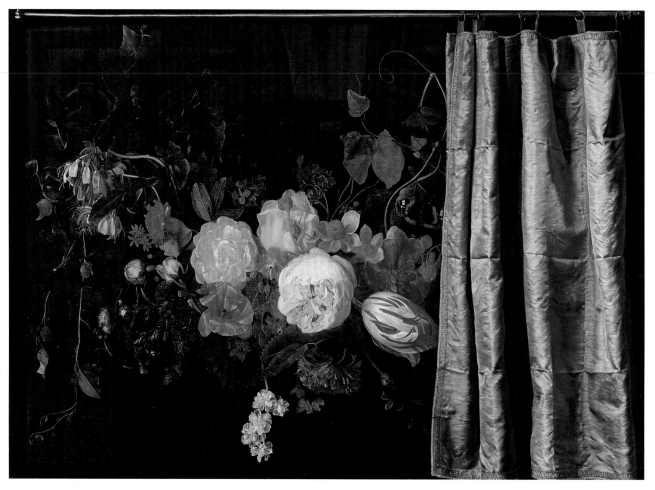

## Trompe l'Oeil Still Life with a Flower Garland and a Curtain

1658

Adriaen van der Spelt (Dutch, 1632–1673)

Frans van Mieris (Dutch, 1633–1681)

Oil on panel; 46.5 x 63.9 cm (18 ¼ x 25 ⅛ in.)

Wirt D. Walker Fund, 1949.585

Flower pieces such as this were among many specialized types of painting that found a ready market in prosperous seventeenth-century Holland. Here, Adriaen van der Spelt produced an artful combination of blooms, including roses, a forget-me-not, a larkspur, and a tulip, flowers with brief seasons that would not coincide in nature. The artifice extends to the painted frame, brass rod, and blue satin curtain. Together, these elements present this choice picture as it might have been displayed in the cabinet of a Dutch collector, protected by a curtain until its owner was ready to show it to an admiring visitor. Here, the shimmering fabric teases the viewer with the possibility of a fuller inspection of the painted flowers.

From the inventory of the collector Henric Bugge van Ring, we know that the painting was a collaboration, with the curtain being the work of Frans van Mieris, who specialized in elegant, moralizing scenes of daily life. The two young authors of this exquisite piece of illusionism, made in the year each joined the Leiden painter's guild, were indulging in a learned statement of their own skill. Indeed, the trick of the painted curtain also recalls Pliny's account of the rivalry between two famous painters of antiquity: while Zeuxis rendered grapes so skillfully that they fooled the birds who tried to eat them, his rival Parrhasios was able to deceive Zeuxis himself with the painted drapery that covered his picture. Holding an honored place in Bugge van Ring's important Leiden picture gallery, the work exemplifies the refined finish and remarkable verisimilitude

that were hallmarks of paintings made in that Dutch city. Such sophisticated productions were at the pinnacle of the contemporary art market and continued to be highly sought after until well into the nineteenth century.

Part of the picture's value would have lain in its casual display of luxury items: silk taffeta imported by Dutch traders and rare floral specimens whose cultivation and scientific description were a national passion. Of these flowers, the tulip, imported into Europe from Turkey in the sixteenth century, was especially valued. Although the speculative tulipmania that had gripped Holland in the 1630s (see p. 62) was only a bad memory by the time Van der Spelt and Van Mieris painted this picture, blooms with flame markings of red on white, one of which is seen here, were still among the most desirable examples of a flower enthusiastically adopted by the Dutch.

MARTHA WOLFF

### *Dish with Long-Tailed Birds in a Garden*
Early/mid-14th century
China, Yuan dynasty (1279–1368)
Porcelain painted in underglaze blue; h. 7.9 cm (3 1/8 in.),
diam. 45.4 cm (17 7/8 in.)
Kate S. Buckingham Fund, 1989.84

With its exuberant underglaze-blue decoration, this fourteenth-century dish represents a decisive turning point in China's long history of high-fired ceramics. Over the previous five hundred years, potters created and steadily refined the world's earliest true porcelains in elegantly proportioned, monochrome-glazed vessels that reflected the subdued tastes of China's imperial court and intellectual aristocracy.[1] This large vessel, by contrast, is the cultural by-product of foreign rule, which had threatened China's very existence when Khubilai Khan (r. 1260–94) conquered all Chinese territory and declared himself emperor of the Yuan dynasty, absorbing China within his vast Mongol Empire. At its height, this multiethnic confederation enveloped most of Asia and extended west to the Black Sea.[2]

However ruthless and authoritative, Yuan rulers were supportive patrons to both Chinese and Mongol artisans. True to their nomadic heritage, they recruited an ethnic melting pot of ceramists, workshop supervisors, and merchants to serve in and beyond the imperial court, fostering the exchange of techniques and styles. In the early and mid-fourteenth century, China's major trading partner was the prosperous, Mongol-controlled Ilkhanid khanate (1256–1353) of present-day Iran, whose otherwise distinctly Persian vessels and architectural tiles of luster-painted fritware frequently display dragons, phoenixes, and other Chinese-inspired decorative motifs.[3]

This thickly molded dish exhibits a comparably hybrid style. Its shallow bowl and flat, bracket-lobed rim, as well as the deep cavetto between them, clearly simulate features of the metal and lusterware platters that Persians used for communal feasts. Encircling the cavetto, a scrolling wreath of lotus blossoms with distinctive, spike-lobed leaves displays a mixture of Chinese and Near Eastern motifs, as does the central composition of a garden in which two birds flirt amidst stylized flowers and fronds. Before glazing and firing, this surface decoration was painted directly onto the white porcelain body with an iron-rich cobalt pigment that is distinctive to the Near East and may have been imported as raw ore from Kashan, in Iran.[4]

Such bold forms and densely vibrant surface decoration were sharp departures from the prevalent tastes of elite Chinese society. That this dish was instead intended for a wealthy Near Eastern client, for dining or perhaps for preservation in a holy shrine, is evident in comparable examples collected in the Topkapi Palace, Istanbul, and the Ardebil Shrine on the shore of the Caspian Sea.[5] Although smaller pieces may have been carried overland to the Near East, objects of this scale were most likely packed as ballast with silks and other luxuries. Shipped from ports along the east coast of China, they would have traveled through the South China Sea and Indian Ocean to destinations along the Persian Gulf and Red Sea.[6]

ELINOR PEARLSTEIN

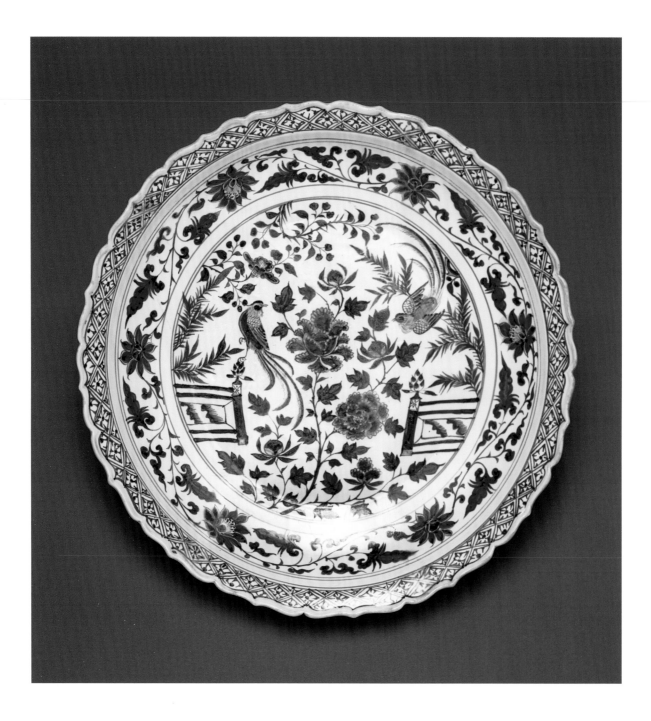

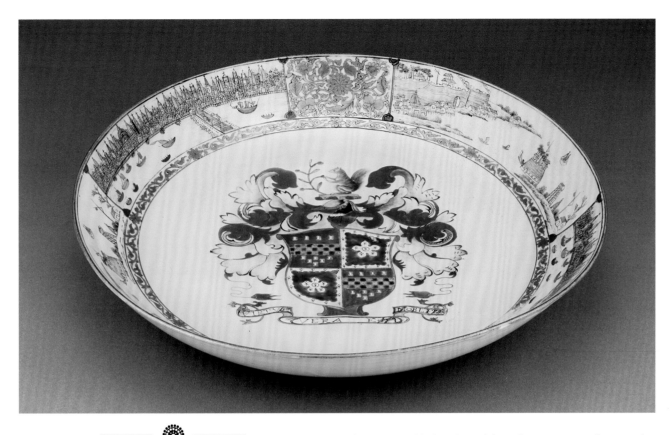

### *Dish*

c. 1730
China, Canton (present-day Guangzhou)
Qing dynasty (1644–1911)
Hard-paste porcelain, enamel, and gilding;
h. 5.7 cm (2 ½ in.), diam. 34.6 cm (13 ⅝ in.)
Gift of Russell Tyson, 1948.94

The importance of the sea trade between England and China is made explicit in the decoration of this large dish, in which panoramic views of London and Canton (present-day Guangzhou) alternate around the broad rim. Beginning in 1600, England established formal commercial relations with the Levant and India, and later with China, under the auspices of the corporation that came to be known as the Honorable East India Company. Shipments moved in both directions: commodities including lead, silver, and wool were sent from England to China, and their sale enabled the purchase of such luxuries as lacquer, porcelain, silk, spices, and tea.[1]

The depictions of London and Canton—each repeated twice—are delineated mainly in black monochrome; the former was likely adapted from late-seventeenth- or early-eighteenth-century prints that found their way to China.[2] The Thames, its width spanned by London Bridge, is shown as the great artery of commerce on which watercraft of all sizes plied their trade. Also visible are the many domes and spires of the City, the financial center of this densely built and prosperous metropolis, which in 1725 boasted a population of around eight hundred thousand.

Canton, located in southern China on the Pearl River, was for centuries the country's most important port and the only one at which Europeans were permitted to trade. Here it is instantly recognizable: at left is the fortified city, its precincts encircled by a tall and crenellated wall, while at right, a circular fort emerges from an island in the river. As the eighteenth century progressed, foreign companies gradually built warehouses, also known as factories or *hongs*, along the unwalled banks of the Pearl; by 1785, this pattern of development resulted in the panorama of flag-bedecked warehouses depicted on the *hong* bowl in the Art Institute's collection (see pp. 68–69).

The dish belongs to a large service made for the wealthy landowner and magistrate Eldred Lancelot Lee or perhaps his son. Like many such porcelains made in China

for Europeans, the Lee commission was personalized with the family arms, painted here with a great flourish and taking up almost the entire center of the dish. Juxtaposing symbols of ancient lineage and modern profit, this object might well have functioned as a memento for the Lees, whose mercantile and military connections suggest just how closely the fortunes and experiences of many British gentry were linked to imperial and commercial expansion. Indeed, the immediate family of Lee's wife, Isabella, included an uncle, Richard Gough, who made many trips to India and China, and built a large fortune trading there; and a brother, Captain Henry Gough, who first sailed to China at age eleven and eventually became a director of the East India Company.[3] Gracing the dining table at Coton Hall, the Lee seat in rural Shropshire, this service would have celebrated both the family's English roots and its ties to a newer, global sphere of wealth and influence.

GHENETE ZELLEKE AND GREGORY NOSAN

### Punch Bowl

c. 1800

China, Qing dynasty (1644–1911)

Hard-paste porcelain, enamel, and gilding

h. 15.2 cm (6 in.), diam. 36 cm (14 3/16 in.)

Purchased by the Antiquarian Society, 1950.3

The exotic goods of China—porcelain, silks, spices, and teas—were highly prized commodities in Europe, whether obtained through commerce along the historical Silk Road or through sea-based trade. Unlike Europeans, who had been dealing firsthand with China since the sixteenth century, American colonists could only obtain Chinese wares indirectly by buying them from Europe. In 1784, however, within a year of independence, the New York–based *Empress of China* reached the port of Macao, near Canton (now Guangzhou), and American merchants took their place among the proprietors of the thirteen factories, or *hongs*, that were allocated to westerners.[1]

This striking punch bowl (also known as a *hong* bowl) is one of the earliest to depict the American flag flying above the factories, poised between those representing Great Britain and the Netherlands.[2] However, unlike the

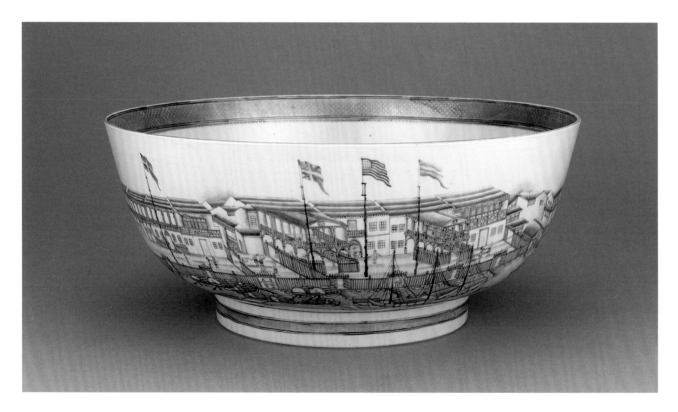

British and Dutch, who organized national companies to trade with China, American businessmen acted as independent agents, sending ships from all the major ports on the Eastern Seaboard. In turn, the Chinese welcomed American merchants, according to Samuel Shaw, an agent on the *Empress of China*, who stated, "when, by the map, we conveyed to them an idea of the extent of our country, with its present and increasing population, they were not a little pleased at the prospect of so considerable a market for the productions of their own empire."[3] By 1830 the United States had become the primary trading partner of the Chinese.[4]

Although less valuable than tea or silks, Chinese export porcelain quickly assumed an important role in American culture, especially because its fine quality could not be replicated by local manufactories. An increasing vogue for tea drinking, as well as a growing fashion for elaborate table settings, stimulated a desire for elegant porcelain wares. While many stock patterns and designs were imported into the United States, Chinese porcelain decorators quickly adapted themselves to the American market, producing goods adorned with nationalistic images, particularly the American eagle.

Chinese painters could also fulfill special requests, copying patterns and designs sent from the United States onto porcelain sets that would be shipped back the following year. Traders and their clients took advantage of the opportunity to request individualized goods decorated with insignias or other personal motifs. Punch bowls such as this one were undoubtedly custom ordered, often by a ship's captain, to commemorate the lengthy voyage to China. Indeed, the captain of the *Empress of China* returned with four *hong* bowls, testimony to these souvenirs' allure.[5]

SARAH E. KELLY

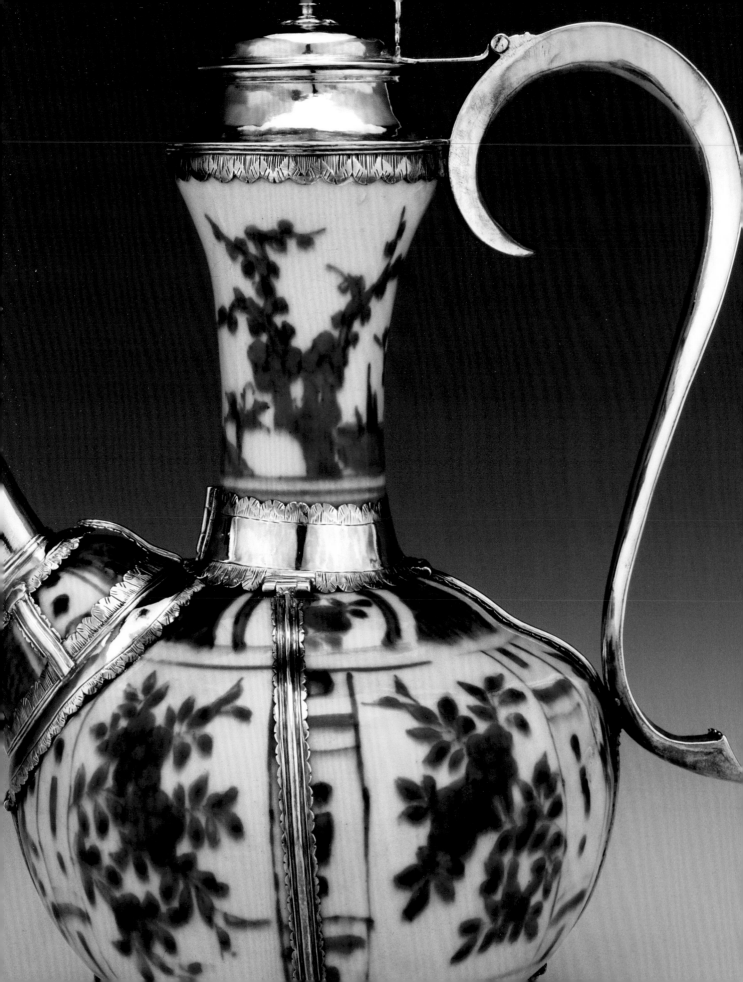

# Transformation

To be transformed is to be significantly altered. A transformation might entail a fundamental change in a person's appearance or attitude, or in the look and function of a thing. The widely varied works appearing in this section document transformations that range from the subtle to the profound, demonstrating just some of the ways in which artists, objects, and creative practices can alter as a consequence of intentional, accidental, and sometimes even unwelcome cross-cultural contact.

Several of the objects included here, the Ethiopian triptych (p. 77) and the Tibetan *thangka* (p. 79) among them, suggest how a region's religious iconography, seemingly timeless, can be transformed by the arrival of other beliefs or representational practices, which blend with indigenous traditions into something altogether new. Sometimes it is folklore that travels from one culture to another, entering and transforming the repertoire of artistic motifs. Such was the case with the griffin, a supernatural beast, part-bird, part-lion, that directly inspired the shape of the Art Institute's bronze protomes (p. 80) and may have influenced the decoration of the museum's majestic bronze bell (p. 82). Of Central Asian origin, tales and images of this fantastic animal found their way thousands of miles west to ancient Greece—and perhaps also east to China.

As these examples indicate, artists have always responded to their experience by adopting different techniques or incorporating novel subjects and traditions. Some, however, have been so fundamentally changed by personal contact with another place or culture that their subsequent creations are different in some essential way from their previous work. For instance, when Henri Matisse encountered North African sunlight, he became mesmerized by its effect on visual perception. Consequently, he expressed his admiration for (and

fascination with) it in both his writing and his visual art, seeking to capture its special quality in works such as *Woman Before an Aquarium* (p. 74). A more dramatic shift occurred in the life and oeuvre of Joseph Beuys. Shot down during World War II, Beuys was sheltered by Crimean nomads, whose medical practices and religious beliefs were alien to him. This episode prompted the artist to create an almost mythic tale about it, and to incorporate into artworks like *Sled* (p. 76) some of the materials his rescuers used to treat and comfort him.

In some cases, it is not the artist, but rather an artwork—or even an art form—that undergoes a transformation. In *Converging Territories*, for instance, Lalla Essaydi challenges the traditional uses of calligraphy within Islamic culture, moving it from the circumscribed world of religious writings into the broader realm of contemporary art (see p. 89). Context also determines meaning in the case of a small ivory box made by Muslim artisans in medieval Sicily (p. 72). As this luxury object passed from private hands to a church treasury, its form was not altered; its function, though, shifted fundamentally from a container for secular goods into a reliquary for sacred remains. Quite the reverse fate befell a pear-shaped, blue-and-white *kendi*, or drinking vessel, which was created in late-sixteenth-century China for export to the Middle East, where it was employed as a *kalian*, or water pipe. By the early seventeenth century, the bottle had made its way to England, where a skilled metalworker adorned it with ornate silver fittings, converting it into a European-style ewer (opposite and p. 73). Although the object's use as a container for liquids remained essentially unchanged, its physical transformations exist as a record of its journey through time and between cultures.

Opposite: Detail of *Ewer* (p. 73).

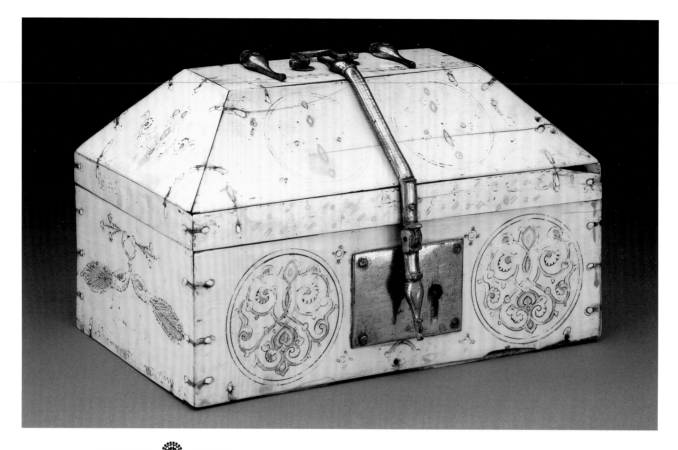

---

### *Casket*

1200/25

Sicily

Ivory, brass, tempera, and gold leaf

9.8 x 15.9 x 9.5 cm (3 7/8 x 6 1/4 x 3 3/4 in.)

Samuel P. Avery Endowment, 1926.389

Over the course of its existence, this ivory casket has witnessed a number of fundamental transformations. At the most elemental level was the working of raw materials into a refined art object, as the thin plaques that form the shell were carved from the thick dentin layer of an African elephant's tusk. Islamic merchants, who participated in the trade network along east Africa's Swahili Coast, obtained the ivory from the interior of southern Africa—where it was most likely swapped in exchange for other precious materials, notably silk and cotton—and transported it through the Indian Ocean, the Red Sea, and, finally, into the Mediterranean.[1]

Sicily, where the box was created, was itself a major hub of Mediterranean trade and therefore a prestigious prize for a succession of medieval conquerors, from the Byzantines to the Fatimids to the Normans. The polyglot visual style of the medieval monuments produced there—from cathedrals to small luxury items such as this—testifies to the island's rich and diverse artistic inheritance.[2] Indeed, the decorative features on this casket clearly indicate that it was produced by a member of the sizeable Muslim community that remained in Sicily under the Normans.

It appears that the artisan in charge of decorating the piece added his own layer of meaning by dramatically enhancing its appearance with gold and vivid tempera colors, now visible only in traces.[3] Using techniques analogous to those employed in ceramic production in other parts of the medieval Islamic world, he also drew upon well-known Eastern motifs such as arabesques, gazelles, peacocks, and the formulaic inscription "May glory endure," which appears in Arabic on the front rim of the cover. This type of deluxe object originally would have been intended to hold jewelry or other valuable items belonging to an affluent household.

The fact that a large number of similar caskets have survived in church treasuries, where they were employed

as reliquaries, speaks to the most radical transformation they often underwent: from secular commodity to spiritual repository. Unlike the Chinese ewer seen below, which was physically altered by an English silversmith to better suit its new context, painted ivory caskets from Norman Sicily were instead subject to a profound metaphysical change.[4] Their status as luxury goods, fabricated from extremely costly materials, made them perfect receptacles for the physical remains of a saint, the most precious of all items to their new Christian owners.

CHRISTINA M. NIELSEN

### Ewer

Porcelain: China, Ming dynasty, Wanli period (1573–1620)
Mounts: English, c. 1610
Hard-paste porcelain with underglaze decoration, silver
h. 26.2 cm (10 5/16 in.)
Gift of Mr. and Mrs. Medard W. Welch, 1966.133

This splendid ewer began its existence as a relatively simple drinking vessel known as a *kendi*, which has a basic shape characterized by a tall neck, a steady base, and a pouring spout attached to the shoulder.[1] While this blue-and-white version was made in the late sixteenth century, the *kendi* form itself appears to be a variation of the *kundika*, which emerged in India in at least the third century B.C.

Originally used to sprinkle water in Buddhist ceremonies of purification, the *kundika* made its way to China, Indonesia, Korea, and Thailand, where it was reinterpreted in a variety of materials and shapes, taking on a wide range of uses, from storing water to dispensing medicine. This example, with its flaring neck, globular base, and especially its breastlike spout, was influenced by the regional forms of Indonesia, where *kendis* were intimately associated with fertility. Indonesia was a major client for wares such as this, so it comes as little surprise that Chinese porcelain manufacturers would have modified their products to fit consumer taste even as they decorated them with Chinese motifs such as the flowering plum branches and fruit clusters that appear on the top and bottom halves of this piece.

Indonesia was not the only market for blue-and-white *kendis*, however, and this one was shipped to the Near East, possibly to Persia, where such vessels were often adapted for use as *kalians*, or water pipes. By the early 1600s, it had made its way to England, most likely imported by the East India Company, which had already established relationships with trading

centers in the eastern Mediterranean. It was in England that this vessel, whose form was already the product of a long history of aesthetic transformations, was altered most dramatically, refitted with silver additions including a dramatic, curving handle and a long, eagle-headed spout. Reaching back to the Middle Ages, the European practice of augmenting Chinese porcelain with silver settings served a number of purposes. In addition to rendering a foreign object suitable for domestic use—in this case, as a wine server—it also served to protect and enhance a treasured material that was, in its translucence and hardness, regarded as jewel-like.[2] Acquired by a wealthy Jacobean collector and embellished by one of the London silversmiths who specialized in such work, this converted *kendi* would have been displayed on a sideboard amidst gold and silver plate, a rarity amongst rarities.

GREGORY NOSAN

## Woman Before an Aquarium

Late 1921 or 1923
Henri Matisse (French, 1869–1954)
Oil on canvas; 80.7 x 100 cm (31 ¾ x 39 ⅜ in.)
Helen Birch Bartlett Memorial Collection, 1926.220

Nearly thirty years after Henri Matisse completed *Woman Before an Aquarium*, he wrote:

> Creation begins with vision. . . . Everything that we see in our daily life is more or less distorted by acquired habits. . . . The effort needed to see things without distortion demands a kind of courage . . . [that] is essential to the artist, who has to look at everything as though he were seeing it for the first time. The work of art is thus the culmination of a long process of development.

The artist takes from his surroundings everything that can nourish his internal vision. . . . He enriches himself internally with all the forms he has mastered and that he will one day set within a new rhythm.[1]

Like many modern artists, Matisse attained this productive freedom in part through contact with non-Western art and culture. His own experiences date to at least 1903, when he visited an Islamic art exhibition at the Musée des Arts Décoratifs, Paris.[2] Although interested in the art of many cultures, he was especially fascinated by that of North Africa and the Middle East, traveling to Munich in 1910 for a major display of Islamic objects and then to the Spanish cities of Madrid, Cordoba, Seville, and Granada to see Moorish architecture. At the same time, Matisse collected art—carpets and fabrics, pottery and tiles—that in their brilliant color and energetic ornament encouraged a fresh approach to seeing the world.

It was, however, the physical experience of North Africa that proved to have the greatest impact on Matisse's vision and creativity. In May 1906, he briefly visited Algeria, describing the experience as "blinding."[3] More time, he explained to artist Henri Manguin, was required to process his sensations into art: "You can't just take up your palette and your method and apply them."[4] He returned to North Africa almost six years later, staying in Morocco for long periods between January 1912 and February 1913. There he came to understand the unique quality of light and its effect on the perception of color and space. "What mellow light," he wrote to Manguin, "but what decorativeness!!! How new all this is, how difficult to render with blue, red, yellow, and green."[5] In vaporous layers of color, Matisse recorded the North African light around him and its powerful ability to break apart form and traditional perspective.

Back in Paris, and later in Nice in the 1920s, these experiences continued to transform Matisse's ways of working. In *Woman Before an Aquarium*, the textile screen and goldfish are examples of "exotic" elements that the artist incorporated into his work.[6] But more subtle and deep was the experience of his travels, translated through time and memory. It is Matisse's own transformation—the "new rhythm" of his inner vision—that is responsible for the particular luminosity, cool palette, and intimate effect of this canvas.

STEPHANIE D'ALESSANDRO

*Sled*
1969
Joseph Beuys (German, 1921–1986)
Wood sled, felt, belts, flashlight, fat, and rope; number 33 of an edition of 50; 35 x 90 x 35 cm (13 ¾ x 35 ³/8 x 13 ³/4)
Twentieth-Century Purchase Fund, 1973.56

As the story has been retold, in 1943 (or 1944, depending on the source), while a volunteer radio operator in the German Luftwaffe, Joseph Beuys was shot down flying over the Crimean Peninsula in the Black Sea, the site of some of the bloodiest battles of World War II, as the Germans attempted to wrest the area from Russian control. He is said to have been rescued by Crimean Tatars—a nomadic, shamanistic people—who covered his body in fat and wrapped it in felt in an attempt to keep him alive until he was able to get to the German field hospital.

There is hardly a discussion of Beuys's oeuvre that does not refer to this personal myth in order to explain his singular iconography and use of particular materials, namely fat and felt, in so much of his work. Initiated by the artist, the oft-quoted tale took on a life of its own to the extent that Beuys himself later began to downplay its significance. Some scholars have disputed its basis in fact altogether, while others have encountered witnesses in the Crimean capital, Simferopol, who claim to recall their brief encounter with the German artist; having "breathed his spirit," they regard him as "their son."[1] However much of the story is fact or fiction, its importance to understanding Beuys's overall project is undeniable, and it invites a discussion of the potentially transformative effect of life experience on artistic creation.

As one in a series of multiples rather than a unique object, *Sled* was born of Beuys's desire to communicate with large numbers of people. Each example is a form of transportation that "carries its own survival kit," as the artist explained—"the flashlight represents the sense of orientation, then felt for protection, and fat is food."[2] In his life's work, which on many levels attempted to come to grips with the identity crisis that Germans faced in the wake of World War II, Beuys developed a complicated yet essentially overly simplistic narrative in which he defined *Eurasia*, a term often used in his titles, as the meeting place of an "analytic" but spiritually vacant West and an idealized, "intuitive" East. Through works such as *Sled*, in which the concepts of energy, healing, medicine, nature,

and political and social change are consistently conflated, Beuys evokes the power of the ritual transformations—artistic and otherwise—that he saw as arising from the exchange of ideas and beliefs across cultures.

LISA DORIN

### Triptych Icon with Central Image of the Virgin and Child

Central Ethiopia
Late 17th century, reign of Iyassu I (1682–1706)
Tempera on linen, mounted on wood and bound with cord
67 x 74 cm (26 ³/₈ x 29 ¹/₈ in.)
Director's Fund, 2006.11

In the highlands of Ethiopia, Orthodox Christianity stretches in an unbroken line of practice from the fourth century to the present day. While painted icons are known from the late fourteenth century, demand increased greatly in the mid-fifteenth, when the worship of Mary was formalized in the Ethiopian Orthodox liturgy. Considered sacred, icons were venerated in weekly services and on special feast days.[1]

This large, finely rendered triptych is one of a small group of paintings in a distinct rendition of the First Gonderine style, which is characterized by flattened compositions with boldly outlined and schematically shaded figures, the linear treatment of drapery and hair, and an emphasis on decorative patterns.[2]

The work's imagery includes fully developed interpretations of standard themes such as the Crucifixion, depicted at top right with the sun and moon, as well as angels collecting Christ's precious blood;[3] at top left, the Ascension with Adam and Eve grasping Christ's robe; and Saint George slaying the dragon, just below.

FIGURE 1. *Salus Populi Romani*, 6th century. Tempera and gold on panel; approx. 152.4 x 99 cm (60 x 39 in.). Santa Maria Maggiore, Rome.

These are combined with innovative iconography that Ethiopian artists had only recently adopted from foreign sources, a development that signaled the integration of the Gonderine Empire into the wider Christian world. One example of this is the central image, in which Mary holds Christ on her lap and grasps a handkerchief in her left hand, while her son blesses her with his right hand and holds a book in his left. This depiction derives from a painting of the Virgin long held in the Basilica of Santa Maria Maggiore, Rome (see fig. 1). Reproduced in portable paintings, the image was disseminated throughout Christendom by missionaries beginning in the early seventeenth century. Upon its arrival in Ethiopia at mid-century, it revolutionized the representation of the Virgin and Child.[4] Here Christ is delicately portrayed wearing a checkered robe and a beautifully detailed cowrie shell necklace.[5] He and Mary sit enthroned on an Ethiopian-style bed, flanked by the archangels Gabriel and Michael.

Similarly, just below the scene of the Crucifixion is a uniquely Ethiopian Orthodox interpretation of Christ Crowned with Thorns known as *Kwer'ata Re'esu* (Striking of His Head). Its source is a sixteenth-century, Flemish-influenced Portuguese painting that became the imperial icon of the Kings of Gonder.[6] In the original painting, Christ appeared with thin, sharp rays of light emanating from his head, a treatment that was used in contemporaneous European depictions of the tormented Christ to heighten the sense of his suffering. Ethiopian clergy and artists interpreted the rays as nails literally being driven into Christ's head by his tormentors.

KATHLEEN BICKFORD BERZOCK

## *Bhaishajyaguru Mandala*
14th century
Central Tibet
Pigment and gold on cotton; 104 x 82.7 cm (41 x 32 ½ in.)
Kate S. Buckingham Endowment, 1996.29

This colorful *thangka*, or scroll painting, represents the Buddha as the master of medicine and teacher of healers.[1] As the Buddhist religion developed, certain schools of thought began to hold that the historical Buddha, Shakyamuni, was only one manifestation of an eternal Buddha who appears in an infinite number of forms.[2] It is from this tradition that Bhaishajyaguru, the Medicine Buddha, originates. Seated in meditation on a lotus flower throne, he wears a stylized version of a monk's red robe. He also displays various conventions—elongated earlobes, a cranial bump, and golden wheels on the palms and feet—that identified the image of the Buddha for over one thousand years. Other features are distinctive to Bhaishajyaguru alone, helping to identify his healing powers. His striking blue complexion represents the stone lapis lazuli, which was believed to cure the three poisons of desire, hatred, and delusion.[3] He also reaches outward with his right hand to bestow a myrobalan plant, the dried fruit of which was prized for its restorative properties.[4]

Buddhist texts mention the Medicine Buddha as early as the third century, and his cult gained widespread popularity as these writings were circulated along the Silk Road.[5] His reception was particularly strong in Tibet, where he was adopted into an already vibrant and uniquely Himalayan visual tradition. The resulting Buddhist images, influenced by the polytheism of Hinduism and indigenous Bon customs, often depict an elaborate pantheon of supportive deities and spiritual helpers.

Some of these beings appear here, embodying a number of divine forces and increasing the potency of Bhaishajyaguru's healing powers. Larger than the rest of the entourage and sharing the Buddha's throne are his two chief bodhisattvas (saintly beings), personifications of solar and lunar radiance. Smaller figures encircle the central trio, each sitting within a niche but forming several carefully composed groups. Among the figures in the top register are seven Medicine Buddhas, while below them a number of bodhisattvas wearing elaborate crowns gather in adoration. Two vertical rows of protective deities riding various animal mounts flank the sides of the *thangka*. These figures derive directly from Hindu gods who were incorporated into the Buddha's service.[6] Along the bottom are two rows of Tibetan Buddhist wealth deities who hold jewel-spitting mongooses; in the two lower corners, four armored figures guard the cardinal directions.[7] Sitting directly below Bhaishajyaguru, between two white lions, is Padmasambhava, the legendary Indian mystic who introduced Tantric Buddhism to Tibet.[8] Exuberant in detail and color, this assembly creates a harmonious mandala, or circle, around Bhaishajyaguru. By reflecting on each figure, Buddhist devotees might meditate on the totality of the Buddha's healing virtues and confront their own pains and afflictions.

TANYA TREPTOW

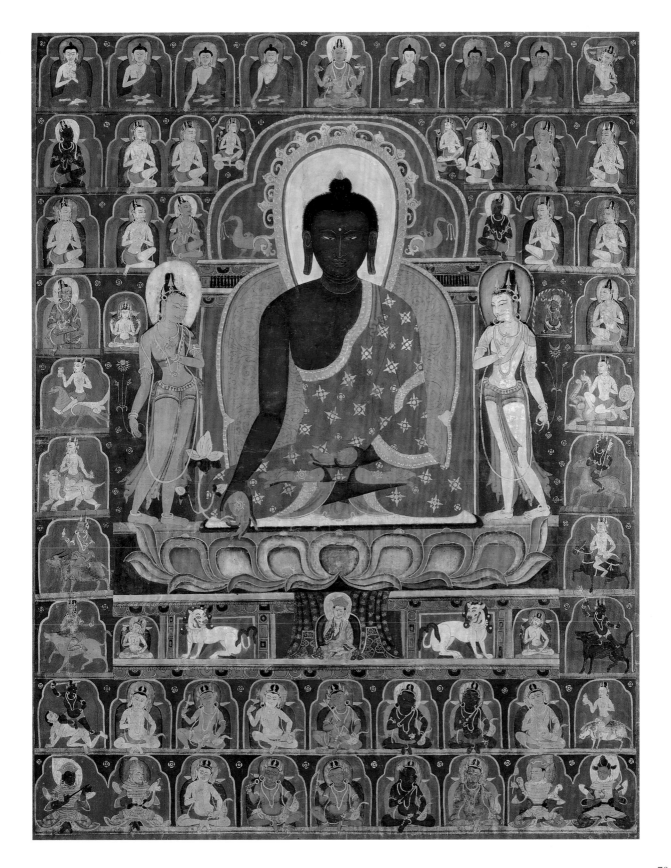

## *Griffin Protomes*

610/600 B.C.

Greek

Bronze and bone or ivory; h. 20.3 cm (8 in.) each

Katherine K. Adler Endowment, 1994.38.1–2

Commercial contact with Asia had a profound impact on the art and culture of Greece during the seventh century B.C., so much so that in modern times it has come to be called the Orientalizing period. The Greeks adopted Near Eastern artistic forms and subjects, as well as religious practices, including the dedication of spectacular bronze cauldrons in their sanctuaries at Olympia and on the Aegean island of Samos.

Spherical vessels of hammered sheet metal, cauldrons were often decorated on their shoulder with a number of cast bronze attachments, or protomes, which were

shaped like the forepart of a hybrid creature, sometimes a siren but usually a griffin. These two exquisitely wrought examples represent griffins, which in their complete form combine the head of a hook-beaked bird with the body of a lion.[1] Here the beasts are depicted in a state of great agitation, eyes wide open and ears erect as they scream an alarm and prepare to lunge at their imaginary adversaries. Like the cauldron form and the ceremonial practices that accompanied it, the iconography of the griffin came to Greece from the East.

About 675 B.C., a Greek by the name of Aristeas set out on an eastward journey that eventually took him to the western slopes of the Altai Mountains.[2] There he came in contact with Saka nomads he called Issedonians, whose lands correspond to the juncture of present-day China, Kazakhstan, Mongolia, and Siberia. They told him a tale about ferocious creatures with avian heads and feline bodies that guarded nests of gold. As preposterous as it sounds, this story, like most folklore, may very well contain a kernel of truth. It is probable that, in their travels, the Issedonians encountered well-preserved, fossilized remains of the beaked and horned protoceratops dinosaur, deposited in fields strewn with gold flakes and nuggets eroded from the nearby mountains. (*Altai*, in fact, means "mountains of gold.")

Because they lacked knowledge of the paleontological past, these ancient peoples observed the physical evidence before them and formulated a story to explain what they could not otherwise understand; at some point, artists illustrated the tale by fashioning an imaginary animal with the dinosaurs' distinctive attributes. The Issedonians may have spread word of this ferocious creature locally to protect their precious resource from treasure hunters. In time, however, their folklore and the image of the griffin migrated along thousands of miles of trade routes to Greece, where the mythical beast, revered for its protective properties, was adopted into the visual repertory.

KAREN MANCHESTER

---
✹
---

## *Bell* (Bo cheng)

1st half of the 5th century B.C.
China, Eastern Zhou dynasty (770–256 B.C.)
Bronze; 62.2 x 43.6 x 36.8 cm (24 ½ x 17 ⅛ x 14 ½ in.)
Lucy Maud Buckingham Collection, 1938.1335

For the nobility of late Bronze Age China, music played a principal role in ceremonies and banquets that honored ancestral spirits and commemorated changing seasons. The assemblages of percussion, strings, and woodwinds that have been unearthed from tombs of the late first millennium B.C. bring vividly to light the visual splendor of these ritual orchestras. The most prominent and durable components of such ensembles are chime sets of bronze bells, which were cast in graduated sizes, decorated identically, and suspended from horizontal beams.[1] Instruments of this type contain no clappers but were struck across their lower panels with wood mallets.[2]

This majestic example displays the richly intricate vocabulary of geometric and zoomorphic motifs that also distinguishes refined bronze vessels from the same period. Tightly interlaced bands, many of which terminate in sharply profiled heads and tails that are each accented by raised curls, embellish the convex sides as well as the top surface.[3] The double-loop suspension device, by contrast, integrates stylized and naturalistic features in an inventive and sculpturally dynamic form in which two creatures with upright, crested heads and open, sharply beaked mouths are positioned back-to-back. Each animal curves backward to swallow its own trunk, from which projects a pair of clawed legs and flat, feathered wings that spread in low relief over the bell's top surface.

Art historians have customarily interpreted these heraldic creatures as either birds or winged dragons.[4] Both Chinese and Western scholars, however, are now beginning to seek possible prototypes in the art and iconography of foreign kingdoms. Some point to the sumptuous rhytons (drinking or libation cups) that were created by Persian silversmiths in about the sixth century B.C. One intriguing counterpart to the Art Institute's bell is a Persian rhyton (collection unknown) with an upturned base that becomes the forepart of a birdlike griffin with a beaked head, round eyes, thrusting chest, broad wings, and sharply clawed feet.[5] Yet the supernatural animals atop this bell bear little resemblance to contemporary Near Eastern images and objects that are also identified as griffins, notably ancient

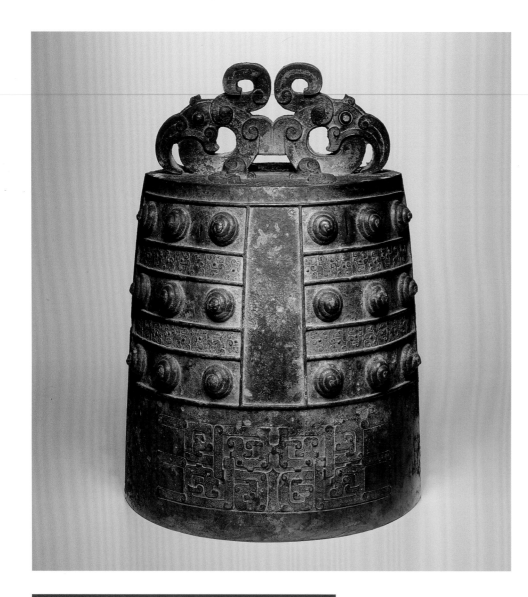

Greek protomes (see pp. 80–81). It is possible that the designer of this bell selectively adapted and transformed seemingly foreign motifs that themselves had been continually reinvented over time and space. In traveling eastward across the vast expanse of southern Siberia and the Mongolian steppe before reaching China's northern frontier, peoples of diverse ethnic and regional groups undoubtedly intermingled, inspiring their craftsmen to create highly innovative images at consecutive stages along the way.[6]

ELINOR PEARLSTEIN

## *Vase (*Maebyong)*

12th century
Korea, Goryeo dynasty (918–1392)
Stoneware with celadon glaze and inlaid decoration
h. 33.3 cm (13 ⅛ in.)
Gift of Russell Tyson, 1950.1626

Celadon wares from the Goryeo dynasty are the hallmark of Korean ceramics, famous for their elegant and often intricate shapes, lush green glazes, and delicately incised or inlaid designs that further embellish the surface. While this vase exemplifies excellence in all these respects, it also embodies a fascinating story of artistic transformation.

As a ceramic glaze, celadon first appeared around the fifteenth century B.C. in China. It probably began as an accident, as kiln ashes fell on an object and were fired into a shiny layer of glassy substance. The iron oxide naturally present in the ashes, when heated in the kiln's oxygen-reduced atmosphere, was responsible for the glaze's greenish hue. This color quickly became the subject of ardent pursuit, which eventually led to the creation of a pure, succulent green. For nearly three thousand years, celadon stoneware remained a favorite type of ceramics in China. In the tenth and eleventh centuries, the taste for celadon spread to Korea, where Chinese wares were enthusiastically emulated. Korean potters went beyond adoption, however, adapting and transforming Chinese models into new, uniquely Korean works of art.

While this form, known as *maebyong* (plum vase), was originally based on a Chinese prototype, it differs from its restrained antecedent in its sensuous profile, which results from a bulging shoulder that tapers theatrically into a graceful, slender body. The small mouth creates a sense of intimacy, contrasting with the expansive grandeur of the shoulder. The reddish tinges amid the green glaze are particular to Goryeo celadon, and the technique of ceramic inlay was a celebrated Korean invention. On the surface of this vase, white and darker green inserts were used to render pictorial designs of clouds, flying cranes, and outdoor scenes that are framed in double-trefoil panels. The one shown here depicts two boys playing in a garden or open field planted with bamboo; one rides a hobbyhorse and triumphantly brandishes a twig (undoubtedly used as a whip), turning around to call for his companion. This, like the other inlaid designs, was as sensitively executed as if it had been painted with a brush and possesses a liveliness that renders the vase immediately adorable. Given the charm of Goryeo celadon, it is small wonder that the Chinese emissary Xu Jing (1091–1153) fell captive to it, heartily praising such works as "first under the heaven," surpassing even those of his native land.

JAY XU

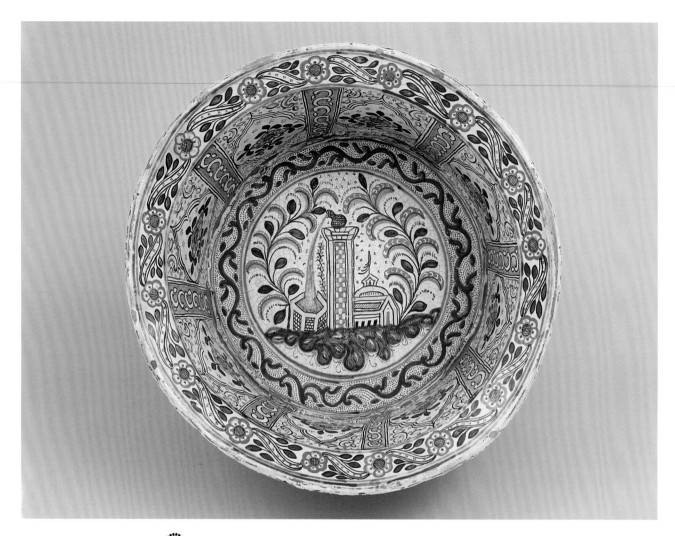

## *Basin*

1700/50

Mexico, Puebla

Tin-glazed earthenware

h. 20 cm (7 ⅞ in.), diam. 55.5 cm (21 ¾ in.)

Gift of Mrs. Eva Lewis in memory of her husband,

Herbert Pickering Lewis, 1923.1502

Barely a decade after the Spanish conquered Aztec Tenochtitlan (present-day Mexico City) in 1521, they founded the city of Puebla de los Angeles sixty miles to the southeast. As colonial society began to take shape, a new visual environment was called into being, supplanting the major forms of native art and affirming the cultural ascendancy of the ruling order. Ceramics became important in this endeavor, and Puebla emerged as the principal center of a thriving pottery industry that included glazed tableware, secular and religious accessories, and tiles used in architectural ornamentation. The imagery of these objects stemmed from opposite ends of the earth, reflecting a New World synthesis that came into being as the Silk Road became global.

Master ceramists from Spain settled in Puebla, bringing with them the potter's wheel as well as tin-glazed earthenware and Hispano-Moresque ornamentation, both originally rooted in the artistic culture of the Islamic world. Indeed, a primary characteristic of the Spanish tradition can be traced to the formative period of Islamic art, which occurred between 800 and 1000. The artists, artisans, and architects charged with the task of creating a visual culture for the new faith did not immediately invent radically original forms; rather, they incorporated motifs and themes from the art of the Roman, Byzantine, and

Persian empires, choosing and adapting from a variety of sources as a new imagery and aesthetic took shape.

In Mexico this inheritance, which in ceramic art placed special value on ornamentation and avoided themes fixed by religious scripture, offered an approach to incorporating another unexpected source of artistic inspiration. During the 1560s, Chinese blue-and-white porcelain, along with other Asian luxury goods, began arriving on galleons from Manila, the new capital of the Spanish Philippines. Unloaded in Acapulco, these objects were transported overland to Mexico City and Puebla— where many of them remained—before continuing on to Veracruz and across the Atlantic to Seville. Chinese wares, with their array of figurative, floral, and geometric forms, had an immediate and lasting impact. In Puebla, a new line of production began, featuring glazed earthenwares freely imitating the imported porcelains while also retaining patterns and shapes deriving from the old Hispano-Moresque tradition.

The Art Institute's basin reflects this layered artistic inheritance: the shape stems from examples made in Egypt, Syria, and Turkey; the ornament derives from Chinese designs; and the filler details spring from the Hispano-Moresque tradition. For instance, the wide, flaring rim is wreathed with pink flowers linked by leafy, scrolling bands adapted from a Chinese motif. The high wall is divided by panels featuring lobed compartments enclosing simplified Chinese peonies; and the surrounding spaces are filled with dotted clusters of Hispano-Moresque origin. The exotic architectural motifs in the central medallion originate in the domed and towered buildings depicted in fanciful Chinese landscape images; here, however, the tower is converted into a fountain surmounted by a native gourd from which water cascades into a cistern. Bold design, vivid color, and playful fantasy characterize this distinctive Mexican synthesis.

RICHARD TOWNSEND

## Teapot
1875/1890
Made by Whiting Manufacturing Company, Newark, New Jersey
Silver and ivory; h. 19.1 cm (7 1/2 in.)
Elizabeth R. Vaughn Fund, 1979.322

This beautiful silver teapot exemplifies one of the late nineteenth century's principal methods of cross-cultural communication: world's fairs. At these international exchanges of commerce, culture, and ideas, Western silver manufacturers advanced their grandest, most innovative designs and found inspiration both in the products and displays of other countries and in the wares of their competitors.[1] Thanks to the opening of trade with Japan in 1854 and the exhibition of Japanese objects at London's 1862 International Exposition, the taste for Japanese-inspired silver swept Europe in the 1860s, finding its way into American homes by the 1870s and 1880s. At

the same time, as Aesthetic Movement designers sought to unshackle themselves from complicated Victorian-era decoration, they also cast their glance toward the Islamic world for stimulation. Hispano-Moresque—popularly known simply as "Moresque"—aesthetics provided an exotic, fresh solution that remained a popular staple from the 1860s into the early 1900s.

The first documented American silver designer to incorporate Islamic motifs was Edward C. Moore of Tiffany and Company, who had a large collection of Persian objects as well as an extensive library on Islamic art from which he could mine source material. In his earliest work in this style, a tea service exhibited at the 1867 Paris Exposition Universelle, he faithfully employed engraved Islamic patterns and intricate, accented scrollwork and finials on a traditional Western teapot form.[2] The two other leading American silver producers of the time, the Gorham and the Whiting manufacturing companies, soon followed suit. Whiting's own chief designer, Charles Osborne, worked for Tiffany's between 1878 and 1887 and may have been influenced by Moore.[3]

This object is an excellent example of the middle phase (lasting from about 1875 to 1885) of American Moresque design: elaborate repoussé work decorates a conventional Western teapot shape with Islamic-inspired variations such as a bulbous base, tapered neck, and slightly rounded top. (In the Middle East, such vessels customarily would have been used for coffee, not tea.) A foundation of ornamental ribbing is crowned by elaborately intertwining vines, which are punctuated by stylized flowers and alternating bands of anthemia on the neck, handle, and spout. The pot also illustrates the changing nature of Hispano-Moresque design: by the 1870s, the shapes and ornamentation were increasingly fanciful, encompassing a number of "oriental" influences from Persia to India to Japan. This pattern may have been a popular one for Whiting—it appears on at least one other known example—and hints at a developing middle-class appetite for personal luxury items such as individual tea services.[4]

<div align="right">Brandon K. Ruud</div>

<div align="center">

*Leaf from a Qur'an*
9th/10th century
North Africa or Near East
Black ink on vellum with red accents
15.5 x 23.3 cm (6 1/8 x 9 3/16 in.)
Text: Sura 5, *al-Ma'ida* (The Repast), verses 88 and 89
Gift of Ann McNear, 1982.1302

</div>

Originally spoken in the northern areas of the Arabian Peninsula, Arabic became an international language after the revelation of the Qur'an in the early seventh century and the subsequent expansion of Islamic society. It was a principal medium of expression for a civilization that extended from the Atlantic Ocean to the coasts of India, and its written form inspired the work of many generations of artists.

Although a simple cursive, or naskhi, script of written Arabic was used in the administration of the early Islamic Empire, refined forms of calligraphy were developed to reflect the special nature of important documents. For Muslims, the foremost of all books was the Qur'an (meaning "reading" or "recitation"), believed to contain the word of God sent from heaven to the Prophet Muhammad. Copies were accordingly revered, and the painstaking task of transcription was often entrusted to masterful artists who transformed an act of copying into an aesthetic statement.[1]

This leaf, taken from a Qur'an made during the Abassid caliphate (750–1258), uses kufic, a spare, angular style of writing that accentuates the sanctity of the text. These verses, for example, discuss important religious obligations such as oath keeping. Although kufic is named for the town of al-Kufah, an early Islamic settlement in southern Iraq, it was widely used and encompasses a whole family of early calligraphic scripts that evolved with subtle variations throughout the Islamic world.[2]

While kufic scripts generally followed a controlled geometry of proportion, many texts have a unique sense of rhythm. The calligrapher of this page had the freedom to stretch and swell some of the characters across the horizontal format of the vellum. Red dots, which are diacritical marks indicating the placement of vowel sounds, also punctuate and minimally decorate the flow of the text. Although the overall style of this leaf is distinctive, its exact provenance is unclear, a common difficulty in the study of early Qur'ans. These texts were

often constructed as portable volumes, suitable for the mobile lifestyles of early Muslims. Many traveled great distances; for example, at an early date, several Qur'ans found in Central Asia were likely transported from North Africa along the Silk Road, fostering stylistic interchange over large regions.[3]

TANYA TREPTOW

### Talismanic Textile

Late 19th/early 20th century
Probably Senegal
Cotton, plain weave; painted; amulets of animal hide and felt
attached by knotted strips of leather
255.2 x 178.8 cm (100 x 70 3/8 in.)
African and Amerindian Purchase Endowment, 2000.326

Islam gradually extended into northern West Africa beginning in the eighth century, carried along the same

trans-Saharan trade routes as the salt and luxury goods that were exchanged for gold, ivory, and slaves. As Muslim traders established themselves in urban centers below the Sahara, local leaders and merchants became increasingly dependent on the intangible commodities that they brought with them, including an extensive network of fellow believers and a code of law governing commerce.[1] However, Arabic literacy was undoubtedly Islam's most powerful import, and its impact was widespread even among those who did not readily convert. Indeed, writing became such a potent force that even the illiterate assimilated it into their visual culture.

In Sufism, a form of Islamic mysticism that is widely practiced in Senegal, the repetition of verses from the Qur'an and even of individual letters or words is a powerful and transcendent form of devotion. This textile is literally saturated with the divine power of the written word. Most overtly, it is covered with Qur'anic verses that were likely recited as they were inscribed in tightly composed Arabic script, thereby forging a link

between the written word and its sound. The calligraphy is arranged in a fluid checkerboard pattern and organized around a series of painted shapes and the extended figure of a quadruped. These shapes, also checkered, evoke magic squares, arrangements of numbers that, when added together in any direction, always amount to the same sum.[2] Sufis view such numerological devices as a powerful reflection of divine mystery. Like words, they are filled with *baraka*, sacred blessings that can help people to negotiate life's challenges.[3] The elongated figure may be read in multiple ways, including as a lizard, a spirit, and a stylized rendering of the name Muhammad.[4] Attached amulets in felt, fur, and leather also punctuate the textile. Commonly these encase small squares of folded paper bearing sacred writing, whether verses from the Qur'an, other religious texts, or magic squares.

Across Senegal, learned Sufi practitioners apply their esoteric knowledge of sacred writing to the therapeutic practices of divination, healing, and spiritual protection. This textile, with its rich combination of imagery, was probably prepared in advance and lent or rented to a client when needed. It reflects a practice that dates to at least the sixteenth century in this region.[5]

KATHLEEN BICKFORD BERZOCK

## *Converging Territories #21*

2004

Lalla Assia Essaydi (Moroccan, born 1956)

Chromogenic color print; number 1 of an edition of 15

57 x 47 cm (22 ½ x 18 ½ in.)

Restricted gift of Anstiss and Ronald Krueck in honor of
Emese and James Wood, 2004.108b

"All my work is autobiographical. I can only work with something that I am acutely aware of or familiar with. And that can only come from my personal experience."[1] So writes Lalla Essaydi, a Moroccan artist living in the West, whose own story is inscribed on the bodies and garments of the women in her photographs. The calligraphy she employs for her narrative is a sacred Islamic art; reserved for poetry and religious texts, it takes many years to master and is traditionally accessible only to men. Yet this male script is painted in henna, a crucial element in celebrating the milestones of female life: a Moroccan woman decorates her hands and feet with henna designs when she reaches puberty, when she becomes a bride, and when she gives birth to her first child. The process of writing on the cloth takes Essaydi weeks, and painting the bodies requires several hours of uninterrupted work.

This picture is the third of a sequence of four that unfolds like Arabic writing, from right to left, depicting stages of womanhood. In the first, a young girl in a tunic bares her head, hands, and feet (all painted with Essaydi's words); in the remaining photographs, as the age of the subjects increases, so does their veiling, until finally the last woman is completely covered. The series is fragmented into separate images just as a book is divided into chapters and pages. The artist drew her inspiration for this format from her own diary, finding that "the need to write grows more and more each time"; accordingly, her recent work has become increasingly segmented.[2]

Essaydi's photographs embody many contrasts, territories that converge: East and West, male and female, writing and decoration, stories and silence. Because she uses calligraphy but subverts it with henna, the writing becomes simultaneously a veil and an expressive statement. A transformation occurs when the words of the mind are inscribed upon the body. As Essaydi brings together these opposing forces in her images, she creates a potential space for a variety of voices to be heard—her narrative is written, while millions of others remain untold.

ELIZABETH SIEGEL

# Notes

**Beach, *The Ear Commands the Story: Exploration and Imagination on the Silk Road*, pp. 8–19.**

The opening epigraph is quoted from Italo Calvino, *Invisible Cities*, trans. William Weaver (Harcourt, Brace, Jovanovich, 1974), p. 135.

1. Daily life is the subject of Susan Whitfield, *Life Along the Silk Road* (University of Chicago Press, 1999); and of Susan Whitfield and Ursula Sims-Williams, eds., *The Silk Road—Trade, Travel, War, and Faith*, exh. cat. (British Library/Serindia Publications, 2004).

2. For a recent discussion, see E. J. W. Barber, *The Mummies of Urumchi* (W. W. Norton, 1999).

3. There it remained a rare luxury material until carefully protected knowledge about its production was smuggled from China to Byzantium in approximately the sixth century.

4. Accounts of their rediscovery in the nineteenth and early twentieth centuries often provide exciting narratives, but the collecting of these remains, which "saved" many objects while further despoiling the sites, identifies a contradiction that is still hotly argued. The tremendous difficulties of exploration and the fierce rivalries among various archaeologists and adventurers are discussed in Peter Hopkirk's immensely readable *Foreign Devils on the Silk Road: The Search for the Lost Cities and Treasures of Chinese Central Asia* (University of Massachusetts Press, 1984).

5. Many of these luxury goods found homes well beyond China. The greatest single repository of Silk Road objects is the Shoso-in, or treasury, at Todai-ji, Japan's largest Buddhist temple, in Nara. At the heart of that collection are works gathered by the Emperor Shomu and presented following his death in 756. In reality, therefore, Japan is also very much a part of the Silk Road.

6. Stanley Sadie, ed., *The New Grove Dictionary of Music and Musicians* (Macmillan, 1980), vol. 4, p. 247.

7. For an immensely lively discussion of Xuanzang and his literary heritage, see Sally Hovey Wriggins, *Xuanzang: A Buddhist Pilgrim on the Silk Road* (Boulder, Colo: Westview Press, 1996).

8. For an excellent, thorough discussion of this topic, see Deborah Howard, *Venice and the East: The Impact of the Islamic World on Venetian Architecture 1100–1500* (Yale University Press, 2000).

9. For more on Ibn Battuta, see Ross E. Dunn, *The Adventures of Ibn Battuta, a Muslim Traveler of the Fourteenth Century* (University of California Press, 1989).

10. Ibid., p. 258.

11. *The Travels of Sir John Mandeville* (Macmillan, 1900).

12. The *Coffee Cantata* is BWV 211. The history of coffee is discussed in Ralph S. Hattox, *Coffee and Coffeehouses: The Origins of a Social Beverage in the Medieval Near East* (University of Washington Press, 1985).

13. The classic discussion of this phenomenon is Edward Said, *Orientalism* (Pantheon, 1978), while a recent rebuttal is the subject of Robert Irwin, *Dangerous Knowledge—Orientalism and Its Discontents* (New York: Overlook Press, 2006).

14. Amartya Sen, *The Argumentative Indian* (Farrar, Straus, and Giroux, 2005), p. 121.

**Travel, pp. 30–49.**

**Horse, pp. 32–33.**

1. Chariots were initially vehicles of status and were used for hunting and later for aristocratic warfare. See Edward L. Shaughnessy, "Historical Perspectives on the Introduction of the Chariot into China," *Harvard Journal of Asian Studies* 48 (1988), pp. 189–237. Shaughnessy noted that the earliest horse-drawn chariots in the Near East appeared about 2000 B.C., entering China from the northwest more than five hundred years later. For a broad survey of horses as documented

in early Chinese literature, see Herlee Glessner Creel, "The Role of the Horse in Chinese History," in *What is Taoism? And Other Studies in Chinese Cultural History* (University of Chicago Press, 1970), pp. 160–86.

2. Creel (note 1), pp. 171–74. Although some scholars have identified the Xiongnu as ancestors of the Huns of Central and Eastern Europe, others now recognize that they did not share a common ethnic, linguistic, or political identity.

3. These expeditions were ordered by Emperor Wudi (r. 141–87 B.C.) and led by his envoy, Zhang Qian. The Yuezhi, who bred the so-called Ferghana horses, had been driven west as far as Bactria; their descendants later founded the Kushan Empire in northern India. Readable accounts of these events appear in Jeanette Mirsky, "Chang Ch'ien: The Han Ambassador to Bactria," in her *The Great Chinese Travelers* (University of Chicago Press, 1964), pp. 13–25; and Luce Boulnois, *Silk Road: Monks, Warriors, and Merchants*, trans. Helen Loveday (Odyssey Books, 2005), pp. 61–71, 75–85. For an authoritative history, see Denis Crispin Twitchett and John King Fairbank, eds., *The Ch'in and Han Empires, 221 B.C.–A.D. 220*, Cambridge History of China 1 (Cambridge University Press, 1986). The collapse of Xiongnu power in the mid-first century B.C. led to the tribe's submission as a vassal or tributary state of Han China.

4. Polo, which may have been introduced to Tang China from Persia, India, Tibet, or Central Asia, is vividly depicted in clay figures and in wall murals from tombs belonging to the Tang imperial family. See *Tang Li Xian mu bihua* (Beijing: Wenwu chubanshe, 1974), pls. 13–18; and Virginia Bower and Colin Mackenzie, "Polo: The Emperor of Games," in *Asian Games: The Art of Contest*, exh. cat. (Asia Society, 2004), pp. 283–88.

5. In addition to the Ferghana Valley, Tang rulers secured horses from broad areas of West Asia, including the regions of present-day Xinjiang, Kyrgyzstan, Khotan, and Afghanistan; Boulnois (note 3), pp. 293–94. In *The Golden Peaches of Samarkand: A Study of Tang Exotics* (University of California Press, 1963), Edward H. Schafer vividly documented China's continual but not always successful quest for these breeds, as well as their real and symbolic allure; see pp. 58–70; see also Creel (note 1), pp. 179–81.

6. For photos of Tang horses found *in situ*, see Zhongguo shehui kexueyun kaogu yanjiusuo bianzhu [Institute of Archaeology, Chinese Academy of Social Sciences], *Chang'an chengjiao Sui Tang mu* [Excavation of the Sui and Tang Tombs at Xi'an] (Beijing: Wenwu chubanshe, 1980), pls. 30:1,32–34, 61.

### Tetradrachm Portraying Alexander the Great, p. 33.

1. Andrew F. Stewart, *Greek Sculpture*, vol. 1, *Text* (Yale University Press, 1990), pp. 186–91.

2. For more on this object, see Theresa Gross-Diaz, "Coin Showing Alexander the Great," *Art Institute of Chicago Museum Studies* 20, 1 (1994), pp. 50–51, cat. 33.

3. A. B. Bosworth, "Alexander and Ammon," in *Greece and the Eastern Mediterranean in Ancient History and Prehistory: Studies Presented to Fritz Schachermeyr on the Occasion of His Eightieth Birthday*, ed. K. H. Kinzl (Walter de Gruyter, 1977), pp. 51–75.

4. For more on this topic, see Andrew F. Stewart, *Faces of Power: Alexander's Image and Hellenistic Politics* (University of California Press, 1993), esp. pp. 318–23.

### Bodhisattva, pp. 34–35.

1. Although the origin of the Buddha image is a much-debated subject, most scholars agree that its first development occurred either in Gandhara or in the neighboring Mathura region of northern India. See David Jongeward, *Buddhist Art of Pakistan and Afghanistan: The Royal Ontario Museum Collection of Gandhara Sculpture*, South Asian Studies Papers 14 (University of Toronto Centre for South Asian Studies, 2003), pp. 16–21.

2. For a review of previous research and debates on the theory of aniconism in early Buddhist art, see Klemens Karlsson, *Face to Face with the Absent Buddha: The Formation of Buddhist Aniconic Art* (Uppsala University, 1999), p. 4.

3. See Pratapaditya Pal, *A Collecting Odyssey: Indian, Himalayan, and Southeast*

*Asian Art from the James and Marilynn Alsdorf Collection*, exh. cat. (Art Institute of Chicago/Thames and Hudson, 1997), p. 307, cat. 158.

4. Jongeward (note 1), p. 54.

### Alexander Comforts the Dying Darius, pp. 35–36.

1. For more on Alexander in the *Shahnama*, see Robert Hillenbrand, "The Iskander Cycle in the Great Mongol *Shahnama*," in *The Problematics of Power: Eastern and Western Representations of Alexander the Great*, ed. Margaret Bridges and J. Christoph Bürgel, Schweitzer Asiatische Studien 22 (Frankfurt: Peter Lang, 1996), pp. 207–09.

2. For more on the Turkman style of illustration, see Basil Robinson, "The Turkman School to 1503," in *The Arts of the Book in Central Asia: 14th–16th Centuries*, ed. Basil Gray (Serindia Publications/UNESCO, 1979), pp. 215–48; and Norah M. Titley, *Persian Miniature Painting and Its Influence on the Art of Turkey and India: The British Library Collections* (British Library/University of Texas Press, 1983), pp. 62–78.

3. John A. Boyle, "Literary Cross-Fertilization between East and West," *Bulletin (British Society for Middle Eastern Studies)* 4, 1 (1977), pp. 32–36.

### Qurban Gul Holding a Photograph of Her Son Mula Awaz, pp. 37–38.

1. Fazal Sheikh, *The Victor Weeps: Afghanistan* (Scalo, 1998), p. 119.

2. Ibid., p. 216.

### Adoration of the Magi, pp. 38–39.

1. For more on this painting, see Christopher Lloyd et al., *Italian Paintings before 1600 in The Art Institute of Chicago: A Catalogue of the Collection*, ed. Martha Wolff (Art Institute of Chicago/Princeton University Press, 1993), pp. 49–53.

### Sketches of the Emperor John VIII Paleologus, a Monk, and a Scabbard, and Bow Case and Quiver of Arrows, pp. 40–41.

1. Suzanne Folds McCullagh, "Sketches of the Emperor John VIII Paleologus, a Monk, and a Scabbard," *Art Institute of Chicago Museum Studies* 30, 2 (2004), p. 27, cat. 10.

2. James A. Fasanelli, "Some Notes on Pisanello and the Council of Florence," *Master Drawings* 3, 1 (Spring 1965), p. 36. A page originally adjacent to this, representing further studies of the Byzantine emperor and his retinue, is in the Musée du Louvre, Paris (MI 1062). Relating to both these drawings is Pisanello's bronze *Medal of John VIII Paleologus*, dating to around 1438/39. It is generally accepted that Pisanello inaugurated the genre of portrait medallions in the Renaissance with this extraordinary work.

3. For an in-depth analysis of these objects and their origins, see Carmen C. Bambach, in Helen C. Evans, ed., *Byzantium: Faith and Power (1261–1557)*, exh. cat. (Metropolitan Museum of Art/Yale University Press, 2004), p. 531.

4. For more on this subject, see Leonardo Olschki, "Asiatic Exoticism in Italian Art of the Early Renaissance," *Art Bulletin* 26, 1 (Mar. 1944), pp. 95–106.

5. See Hermann Goetz, "Oriental Types and Scenes in Renaissance and Baroque Painting," *Burlington Magazine* 73, 426 (Sept. 1938), pp. 50–62, 105–15.

6. Julian Raby, *Venice, Dürer and the Oriental Mode*, Hans Huth Memorial Studies 1 (London: Islamic Art Publications, 1982), p. 18.

7. Dürer sojourned in Venice between 1494 and 1495, and again from 1505 to 1507. On his Eastern subjects, see ibid., pp. 22–34; and Bernard Aikema and Beverly Louise Brown, *Il Rinascimento a Venezia e la pittura del Nord ai tempi di Bellini, Dürer, Tiziano*, exh. cat. (Milan: Bompiani, 1999).

### Ismael, the Ambassador of Tahmasp, King of Persia, pp. 41–42.

1. For an account of Lorichs's travels, see Erik Fischer, *Melchior Lorck: Drawings from the Evelyn Collection at Stonor Park, England, and from the Department of Prints and Drawings, the Royal Museum of Fine Arts, Copenhagen*, exh. cat. (Copenhagen: A. W. Henningsen, 1962), pp. 13–37.

2. Patricia L. Baker, *Islamic Textiles* (British Museum Press, 1995), p. 113.

3. This engraving (1920.2317) is presently unpublished.

### Shiva Nataraja, pp. 42–43.

1. For more on Chola development of the iconography of dancing Shiva, see Vidya Dehejia et al., *The Sensuous and the Sacred: Chola Bronzes from South India*, exh. cat. (American Federation of Arts/University of Washington Press, 2003), pp. 94–105. Some of the earlier forms of the dancing Shiva are seen in Calembus Sivaramamurti, *Nataraja in Thought, Art, and Literature* (New Delhi: National Museum, 1974), pp. 168–220. For more on this statue in particular, see Pratapaditya Pal, "Sculptures from South India in the Art Institute of Chicago," *Art Institute of Chicago Museum Studies* 22, 1 (1996), p. 26, fig. 6.

2. One of the most formative influences on current scholarship addressing the symbolic significance of Shiva's dance has been Ananda K. Coomaraswamy, "The Dance of Shiva," in *The Dance of Shiva: Fourteen Indian Essays*, 2d ed. (New Delhi: Mushiram Manoharlal, 1970), pp. 83–95. For more recent thinking, see Padma Kaimal, "Shiva Nataraja: Shifting Meanings of an Icon," *Art Bulletin* 81, 3 (Sept. 1999), pp. 390–419.

### Virgin and Child Enthroned with the Archangels Raphael and Gabriel and Christ on the Cross between the Virgin and Saint John the Evangelist, pp. 44–45.

1. On the Crusades, see Jonathan Riley-Smith, ed., *The Oxford History of the Crusades* (Oxford University Press, 1999); and Carole Hillenbrand, *The Crusades: Islamic Perspectives* (Routledge, 2000).

2. For more on this diptych, see Christopher Lloyd et al., *Italian Paintings before 1600 in The Art Institute of Chicago: A Catalogue of the Collection*, ed. Martha Wolff (Art Institute of Chicago/Princeton University Press, 1993), pp. 131–35; and Helen C. Evans, ed., *Byzantium: Faith and Power (1261–1557)*, exh. cat. (Metropolitan Museum of Art/Yale University Press, 2004), p. 479, cat. 288.

3. On Crusader art in general, see Hugo Buchthal, *Miniature Painting in the Latin Kingdom of Jerusalem* (Clarendon Press, 1957); Bianca Kühnel, *Crusader Art of the Twelfth Century: A Geographical, an Historical, or an Art Historical Notion?* (Berlin: Mann, 1994); and Jaroslav Folda, *Crusader Art in the Holy Land, From the Third Crusade to the Fall of Acre, 1187–1291* (Cambridge University Press, 2005).

4. See Oleg Grabar, "The Shared Culture of Objects," in *Byzantine Court Culture from 829 to 1204*, ed. Henry Maguire (Dumbarton Oaks Research Library and Collection/Harvard University Press, 1997), pp. 115–29.

5. For discussions and illustrations of these works, see Evans (note 2), pp. 462–63, cat. 272, and pp. 466–67, cat. 276.

6. For more on these, see Lloyd (note 2), p. 134; and Evans (note 2), p. 479.

7. Evans (note 2), p. 479.

8. Ibid., and Lloyd (note 2), p. 134.

### European Banquet Scene, pp. 46–48.

1. For more on Mughal art, see Milo C. Beach, with contributions by Stuart Cary Welch and Glenn D. Lowry, *The Grand Mogul: Imperial Painting in India, 1600–1660*, exh. cat. (Sterling and Francine Clark Art Institute, 1978); and Jorge Flores and Nuno Vassallo e Silva, eds., *Goa and the Great Mughal*, exh. cat. (Scala, 2004).

2. Milo C. Beach, "A European Source for Early Mughal Painting," *Oriental Art* 22 (1976), pp. 181–84.

3. For more on Akbar and his reign, see Iqtidar Alam Khan, ed., *Akbar and His Age* (New Delhi: Northern Book Centre, 1999); and Michael Brand and Glenn D. Lowry, eds., *Akbar's India: Art from the Mughal City of Victory*, exh. cat. (Asia Society, 1985).

4. For more on these Jesuit missions, see Gauvin Alexander Bailey, *The Jesuits and the Grand Mogul: Renaissance Art at the Imperial Court of India, 1580–1630*, Occasional Papers (Freer Gallery of Art) 2 (Smithsonian Institution, 1998); and idem, "*The Truth-Showing Mirror*: Jesuit Catechism and the Arts in Mughal India," in *Jesuits: Cultures, Sciences, and the Arts, 1540–1773*, ed. John W. O'Malley (University of Toronto Press, 1999), pp. 380–401.

### Crossroads, pp. 48–49.

1. For more on Spiegelman, see Avis Berman, "Art Spiegelman: The Maus that Roared," *ARTnews* 92, 5 (May 1993), p. 64.

### Trade, pp. 50–69.

### Equestrian and Four Figures, pp. 52–53.

1. The most exotic archaeological finds include, at the ancient city of Jenné-jeno in Mali, a glass bead of a type currently known only from South and Southeast Asia and contemporary to the Han dynasty of China (206 B.C.–A.D. 220); see Susan Keech McIntosh, ed., *Excavations at Jenné-Jeno, Hambarketolo, and Kaniana (Inland Niger Delta, Mali): The 1981 Season*, University of California Publications in Anthropology 20 (University of California Press, 1994), p. 390. Discovered at Gao, also in Mali, were a red carnelian bead that may have originated as far away as India and a fragment of southern Chinese porcelain dated to between the sixteenth and seventeenth century; see Timothy Insoll, "Trade and Empire: the Road to Timbuktu," *Archaeology* 53, 6 (Nov./Dec. 2000), pp. 50–51. A sherd of southern Chinese celadon dated to the late eleventh or early twelfth century and a fragment of a colored glass bracelet similar to those from Egypt and dating to the fourteenth century were excavated at Timbuktu; see ibid. pp. 51–52. Insoll described his archaeological work in greater detail in *Islam, Archaeology, and History: Gao Region (Mali) ca. A.D. 900–1250*, Cambridge Monographs in African Archaeology 39 (Oxford: Tempus Reparatum, 1996).

2. At its apex in the fourteenth century, the Kingdom of Mali extended from the west coast to the bend of the Niger River and from the desert's edge to the fringes of the rain forest.

3. Insoll 2000 (note 1), pp. 49–50.

4. Abraham Cresques, *Mapamundi: The Catalan Atlas of the Year 1375*, ed. Georges Grosjean (Zurich: Dietikon, 1978), p. 63. The Catalan Atlas comes from the Mediterranean island of Mallorca and was probably drawn by Abraham Cresques; see also Jean Michel Messing, "Observations and Beliefs: the World of the Catalan Atlas," in *Circa 1492, Art in the Age of Exploration*, ed. Jay A. Levenson, exh. cat. (National Gallery of Art, Washington D.C./ Yale University Press, 1991), pp. 27–39.

5. G. Szumowski, "Pseudotumulus des Environs de Bamako," pt. 1, *Notes Africaines* 75 (1957), pp. 66–73; and idem, "Pseudotumulus des Environs de Bamako," pt. 2, *Notes africaines* 77 (1958), pp. 1–11.

6. Some Bankoni figures have been found in conjunction with stone mounds that are believed to have had ritual significance and many, including these, appear to have been intentionally broken. It is likely that these were conceived as a group and were buried together within or beneath such a mound.

### Mirror Frame, pp. 53–54.

1. Quoted in Manuel Keene, *Treasury of the World: Jewelled Arts of India in the Age of the Mughals*, exh. cat. (Kuwait National Museum/Thames and Hudson, 2001), pp. 30–43.

2. On Mughal jades, see Teng Shu-p'ing, *Catalogue of a Special Exhibition of Hindustan Jade in the National Palace Museum*, exh. cat. (Taipei: National Palace Museum, 1983), esp. pp. 76–83; and Robert Skelton, "Islamic and Mughal Jades," in *Jade*, ed. Roger Keverne (London: Anness Publications, 1991), esp. pp. 274–91.

### Serving Table, pp. 54–55.

1. For more on Lockwood de Forest, see Roberta Ann Mayer, "Understanding the Mistri: The Arts and Crafts of Lockwood de Forest (1850–1932)" (Ph.D diss., University of Delaware, 2000).

2. Lockwood de Forest, *Indian Architecture and Ornament* (Boston: George H. Polley, 1887), n. pag.

3. This table is not one of the standard forms De Forest offered, so it was likely custom ordered by the Princeton, New Jersey, family that originally owned it.

4. In this case, the work was likely done by the cabinetmaker John Spielberg,

who executed the bulk of De Forest's "East Indian" designs in New York for more than two decades. Spielberg occasionally dealt directly with De Forest's clients on his behalf, and the designer later recalled that he was "one of the best cabinetmakers I have ever found." See Lockwood de Forest to M. Carey Thomas, Nov. 6, 1905, M. Carey Thomas Papers, Bryn Mawr College, microfilm 156; quoted in Mayer (note 1), p. 175.

### Chair (Kiti Cha Enzi), pp. 55–56.

1. See Michael N. Pearson, *Port Cities and Intruders: The Swahili Coast, India, and Portugal in the Early Modern Period* (Johns Hopkins University Press, 1998), pp. 51–54; and Chapurukha M. Kusimba, *The Rise and Fall of Swahili States* (Walnut Creek, Calif.: AltaMira Press, 1999), pp. 68–69.
2. Pearson (note 1), pp. 40–41.
3. Ibid., pp. 47–51; Kusimba (note 1), pp. 35–38.
4. Kusimba (note 1), pp. 193–97.
5. Ibid., p. 174.
6. See Bernardo Ferrão, *Mobiliario Portugues: Dos Primordios ao Maneirismo*, vol. 3, *India e Japao* (Porto: Lello and Irmão, 1990), pp. 53–56; and James de Vere Allen, "The Kiti Cha Enzi and Other Swahili Chairs," *African Arts* 22, 3 (May 1989), pp. 54–63.
7. Allen (note 6).
8. Ibid.
9. Ibid., p. 62.

### Women Engaged in the Sericulture Industry (Joshoku kaiko tewaza-gusa), pp. 56–57.

1. Asano Shûgô and Timothy Clark, *Kitagawa Utamaro* (Tokyo: Asahi Shinbunsha, 1995), p. 205. For more on Utamaro's prints on the subject of sericulture, see James T. Ulak, "Utamaro's Views of Sericulture," *Art Institute of Chicago Museum Studies* 18, 1 (1992), pp. 72–84.

### Empress's Jifu (Semiformal Court Robe), pp. 58–59.

1. For more on the history of silk and sericulture in China, see James C. Y. Watt and Anne E. Wardwell, *When Silk Was Gold: Central Asian and Chinese Textiles*, exh. cat. (Metropolitan Museum of Art/Harry N. Abrams, 1997); James C. Y. Watt, *China: Dawn of a Golden Age, 200–750 A.D.* (Metropolitan Museum of Art/Yale University Press, 2005); and Susan Whitfield, *The Silk Road: Trade, Travel, War, and Faith* (British Library/Serindia Publications, 2004).
2. Luce Boulnois, *Silk Road: Monks, Warriors, and Merchants*, trans. Helen Loveday (Odyssey Books, 2005), esp. pp. 179–85.
3. For more on the political and ritual significance of Chinese textiles, particularly those in the Art Institute's collection, see John E. Vollmer, "A Chinese Universe of Textiles," *Art Institute of Chicago Museum Studies* 26, 2 (2000), pp. 13–51, esp. pp. 31–36.

### Saints John the Baptist and Catherine of Alexandria, pp. 59–60.

1. For an introduction to Italian trade with Asia in this period, see Rosamond E. Mack, *Bazaar to Piazza: Islamic Trade and Italian Art, 1300–1600* (University of California Press, 2002), pp. 15–25.
2. For a brief introduction to fourteenth-century Venetian painting, see John Steer, *A Concise History of Venetian Painting* (Thames and Hudson, 1979), pp. 15–34. *Saints John the Baptist and Catherine of Alexandria* is also published, along with *Saints Augustine and Peter* (1958.304), another panel from the same unknown polyptych, in Christopher Lloyd et al., *Italian Paintings before 1600 in The Art Institute of Chicago: A Catalogue of the Collection*, ed. Martha Wolff (Art Institute of Chicago/Princeton University Press, 1993), pp. 185–89. For more on Paolo Veneziano, see Filippo Pedrocco, *Paolo Veneziano* (Paris: La Renaissance du Livre, 2003), esp. pp. 192–93, cats. 24/1–2; and Francesca Flores d'Arcais and Giovanni Gentili, *Il Trecento adriatico: Paolo Veneziano e la pittura tra Oriente e Occidente*, exh. cat. (Rimini: Castel Sismondo/Milan: Silvana, 2002).

3. For a thorough study of the presence of patterned silks in Italy and the role of pseudo-Asian script in Italian paintings, see Mack (note 1), pp. 27–71; see also Brigitte Klesse, *Seidenstoffe in der italienischen Malerei des 14. Jahrhunderts*, Schriften der Abegg-Stiftung Bern 1 (Bern: Stämpfli, 1967).

### Fragment, pp. 60–61.

1. James C. Y. Watt and Anne E. Wardwell, *When Silk Was Gold: Central Asian and Chinese Textiles*, exh. cat. (Metropolitan Museum of Art/Harry N. Abrams, 1997), p. 9.
2. Olivia Remie Constable, *Trade and Traders in Muslim Spain: The Commercial Realignment of the Iberian Peninsula, 900–1500* (Cambridge University Press, 1994), p. 223.
3. Florence Lewis May, *Silk Textiles of Spain: Eighth to Fifteenth Century* (Hispanic Society of America, 1957), pp. 3, 7. For examples of early Spanish woven silks, see Cristina Partearroya, "Almoravid and Almohad Textiles," in *Al-Andalus: The Art of Islamic Spain*, ed. Jerilyn Denise Dodds, exh. cat. (Metropolitan Museum of Art/Harry N. Abrams, 1992), pp. 105–13.
4. For an example in the Art Institute's collection, see Christina M. Nielsen, "Fragment of Doña Leonora's Mantle," *Art Institute of Chicago Museum Studies* 30, 2 (2004), pp. 25–26, cat. 8.
5. Avinoam Shalem, *Islam Christianized: Islamic Portable Objects in the Medieval Church Treasuries of the Latin West*, Ars faciendi 7 (Frankfurt: Peter Lang, 1996); and Sheila S. Blair and Jonathan M. Bloom, "From Secular to Sacred: Islamic Art in Christian Contexts," in *Secular Sacred: 11th–16th Century Works from the Boston Public Library and the Museum of Fine Arts, Boston*, ed. Nancy Netzer, exh. cat. (McMullen Museum of Art, Boston College/University of Chicago Press, 2006), pp. 115–19.
6. Dorothy Shepherd, "A Twelfth-Century Hispano-Islamic Silk," *Bulletin of the Cleveland Museum of Art* 3 (1951), pp. 59–62; and Avinoam Shalem, "From Royal Caskets to Relic Containers: Two Ivory Caskets from Burgos and Madrid," *Muqarnas* 12 (1995), pp. 24–38.

### Tankard, pp. 61–62.

1. For more information on the origin and development of the Iznik ceramic industry, see Nurhan Atasoy and Julian Raby, *Iznik: The Pottery of Ottoman Turkey*, ed. Yanni Petsopoulos (London: Alexandria Press/Laurence King, 1989); and J. J. Henderson and Julian Raby, "The Technology of Fifteenth Century Turkish Tiles: An Interim Statement on the Origins of the Iznik Industry," *World Archaeology* 21, 1 (June 1989), pp. 115–32.
2. John H. Harvey, "Turkey as a Source of Garden Plants," *Garden History* 4, 3 (Autumn 1976), p. 21.
3. See Sheila S. Blair and Jonathan M. Bloom, *Images of Paradise in Islamic Art*, exh. cat. (Hanover, N.H.: Hood Museum of Art, 1991), pp. 15–17.
4. For more on the phenomenon of tulipmania in both Europe and the Ottoman Empire, see Mike Dash, *Tulipomania: The Story of the World's Most Coveted Flower and the Extraordinary Passions It Aroused* (Crown Publishers, 1999); and Peter M. Garber, "Tulipmania," *Journal of Political Economy* 97, 3 (June 1989), pp. 535–60.

### Panel, p. 63.

1. On Ottoman woven silks, see Nurhan Atasoy et al., *Ipek: Imperial Ottoman Silks and Velvets* (London: Azimuth Editions, 2001); J. M. Rogers, *Empire of the Sultans: Ottoman Art from the Collection of Nasser D. Khalili* (Geneva: Musée d'Art et d'Histoire/London: Nour Foundation and Azimuth Editions, 1995), pp. 204–13; Philippa Scott, in Ahmed Ertûg et al., *Reflections of Paradise: Silks and Tiles from Ottoman Bursa* (Istanbul: A. Ertûg and A. Kocabiyik, 1995), pp. 188–244; and Patricia L. Baker, *Islamic Textiles* (British Museum Press, 1995), pp. 85–105.
2. During the reign of Mehmed II (1451–81), the court purchased some 110,000 ducats' worth of Italian cloth; see Baker (note 1), p. 92.
3. Rosamond E. Mack, *Bazaar to Piazza: Islamic Trade and Italian Art, 1300–*

*1600* (University of California Press, 2002), p. 46.

4. Rogers (note 1), p. 204.

### Dish with Long-Tailed Birds in a Garden, pp. 65–66.

1. For experiments with underglaze blue as early as the Tang dynasty (618–907), when cobalt may have been mined domestically or imported from the Near East, see Rosemary Scott, "A Remarkable Tang Dynasty Cargo," *Transactions of the Oriental Ceramic Society* 67 (2002/03), pp. 13–26, figs. 1–6; and Rose Kerr and Nigel Wood, *Science and Civilization in China*, vol. 5, *Chemistry and Chemical Technology* (Cambridge University Press, 2004), pp. 668–76.

2. For more on Khubilai Khan, see Morris Rossabi, *Khubilai Khan: His Life and Times* (University of California Press, 1988); and idem, "The Mongols and Their Legacy," in *The Legacy of Genghis Khan: Courtly Art and Culture in Western Asia, 1256–1353*, ed. Linda Komaroff and Stefano Carboni, exh. cat. (Metropolitan Museum of Art/Yale University Press, 2002), pp. 12–35.

3. Ceramics such as these indicate that Ilkhanid rulers may well have recruited Chinese artisans to work in Iran. See Priscilla P. Soucek, "Ceramic Production as Exemplar of Yuan-Ilkhanid Relations," *Res* 35 (Spring 1999), pp. 125–41; and Rossabi 2002 (note 2) pp. 34–35. Likewise, Chinese court records testify to the presence of both administrators and craftsmen from the Near East at the Imperial Bureau of Manufacture, which oversaw production at the imperial kilns at Jingdezhen, located in southeastern Jiangxi Province. See Liu Xinyuan, "Yuan Dynasty Official Wares from Jingdezhen," in Rosemary Scott, ed., *The Porcelains of Jingdezhen*, Colloquies on Art and Archaeology in Asia 16 (London: Percival David Foundation of Chinese Art, 1993), pp. 33–46.

4. Although not documented, Kashan is cited most frequently as China's probable source of cobalt in the fourteenth century; this color is often termed "Mohammedan blue." See Kerr and Wood (note 1), pp. 676–80. Others, however, postulate that some Yuan cobalt originated in far western China; see Chen Yaocheng, Gao Yanyi, and Chen Hong, "Sources of Cobalt Pigment Used on Blue and White Porcelain Wares," *Oriental Art* 60, 1 (Spring 1993/94), pp. 14–19.

5. The Topkapi Palace (now the Topkapi Saray Museum), founded in the late fifteenth century, and the Ardebil Shrine, a fourteenth-century funerary complex to which the Safavid ruler Shah Abbas dedicated his porcelains in 1611, both include large and stunning examples of late Yuan blue and white. Those originally in the shrine are presently held at the Iran Bastan Museum, Tehran. For large dishes with floral and/or pictorial motifs comparable to those on the Art Institute's dish, see Regina Krahl, *Chinese Ceramics in the Topkapi Saray Museum, Istanbul: A Complete Catalogue* (Sotheby Publications/Topkapi Saray Museum), esp. vol. 2, pp. 481–83, cats. 560, 562, 564–65; John Alexander Pope, *Chinese Porcelains from the Ardebil Shrine*, 2d ed. (Sotheby Parke Bernet, 1981); and Takatoshi Misugi, *Chinese Porcelains in the Near East: Topkapi and Ardebil* (Hong Kong University Press, 1981).

6. Sherds of blue and white have been excavated in all of these areas. For a reconstruction of both land and sea routes as well as technical and historical commentary, see John Carswell, *Blue and White: Chinese Porcelain Around the World* (British Museum Press, 2000), pp. 11–79. The original owner of this dish is unknown. The Arabic name Hasan ibn Muhammad (Hasan, son of Muhammad), inscribed in ink twice on the reverse, most likely identifies a later collector but does not name a specific individual.

### Dish, pp. 67–68.

1. For more on the East India Company, see John Keay, *The Honourable Company: A History of the English East India Company* (Harper Collins, 1993); Philip Lawson, *The East India Company: A History* (Longman, 1993); and H. V. Bowen, Margarette Lincoln, and Nigel Rigby, eds., *The Worlds of the East India Company* (Boydell Press, 2006). For Chinese export porcelain, see David Howard and John Ayers, *China for the West: Chinese Porcelain and Other Decorative Arts for Export Illustrated from the Mottahedeh Collection* (Sotheby Parke Bernet, 1978); esp. p. 204, cat. 203, and p. 404, cat. 403.

2. The most studied object commissioned by the Lee family is Joseph Highmore's famous portrait *Mrs. Eldred Lancelot Lee and Her Eleven Children* (1736; Wolverhampton Art Gallery), the largest he is known to have painted. For more on this picture and the Lees, see Alison Shepherd Lewis, "Joseph Highmore, 1692–1780: An Eighteenth-Century English Portrait Painter" (Ph.D. diss., Harvard University, 1975), pp. 138–39, 448–51.

3. Isabella Lee's siblings also included a brother, Richard Gough, captain of the trading ship *Severn*, who died in India in 1712. The Lees' oldest daughter, Isabella, herself moved to India with her husband, George Hurst, a surgeon. The family's connections may have penetrated into the Western Hemisphere as well: another daughter, Mary, married Colonel John Littlehales, who appears to have commanded the British Fort Oswego on Lake Ontario during the French and Indian War. For more on the Lee and Gough families, see "Portrait of a Family," Wolverhampton Art Museum (2005), http://www.wolverhamptonart.org.uk/ art_insight/art/family; "The Goughs of Oldfallings," http://www.localhistory. scit.wlv.ac.uk/articles/bushbury/families/gough.htm; and "Gough/Goff History and Genealogy," http://www.scit.wlv.ac.uk/~cm1822/gough6.html.

### Punch Bowl, pp. 68–69.

1. Foreign merchants, or factors, were restricted to a small parcel of land containing the factories, which served them as residence, office, and storehouse during the months they were engaged in business. For further information on the China Trade, particularly on the participation of the United States, see Ronald W. Fuchs II in collaboration with David S. Howard, *Made in China: Export Porcelain from the Leo and Doris Hodroff Collection at Winterthur* (Henry Francis du Pont Winterthur Museum/University Press of New England, 2005), p. 26.

2. Several factors suggest that the Art Institute's bowl was painted shortly after the Americans entered the China Trade. First, the American flag here displays thirteen stars; the fifteen-star flag was not adopted until 1795. However, the lengthy production and shipping process meant that such details would only slowly be incorporated into ceramic imagery. Second, the French flag appears among the factories, implying that the bowl was painted before the French left the China Trade in 1802. Finally, the position of the flag on the Art Institute's bowl suggests that it was painted before American traders established a permanent factory next to that of Sweden. For more, see David Sanctuary Howard, *New York and the China Trade* (New-York Historical Society, 1984), p. 77.

3. Quoted in Fuchs and Howard (note 1), p. 27.

4. The increased primacy of Americans in the China Trade must also be attributed to a slackening demand for export porcelain in Great Britain; see John Goldsmith Phillips, *China-Trade Porcelain: An Account of Its Historical Background, Manufacture, and Decoration and a Study of the Helena Woolworth McCann Collection* (Metropolitan Museum of Art/Harvard University Press, 1956), p. 41.

5. The cargo manifest included "4 Factory Painted Bowles @ 5 ½ [dollars] each"; see Howard (note 2).

### Transformation, pp. 70–89.

### Casket, pp. 72–73.

1. For more on the Swahili Coast, see Mark R. Horton, "The Swahili Corridor," *Scientific American* 257, 3 (1987), pp. 86–93; and idem, *Shanga: The Archaeology of a Muslim Trading Community on the Coast of East Africa*, Memoir 14 (London: British Institute in Eastern Africa, 1996).

2. See, for example, William Tronzo, *The Cultures of His Kingdom: Roger II and the Capella Palatina in Palermo* (Princeton University Press, 1997).

3. For more on similar caskets, see Perry Blythe Cott, *Siculo-Arabic Ivories*, Princeton Monographs in Art and Archaeology Folio Series 3 (Department of Art and Archaeology, Princeton University, 1939), p. 33, no. 18, and pl. 7; José Ferrandis Torres, *Marfiles árabes de occidente*, vol. 2 (Madrid: E. Maestre, 1940), pp. 169–70, pl. 39; and Ralph H. Pinder-Wilson and C. N. L. Brooke, "The Reliquary of Saint Petroc and the Ivories of Norman Sicily," *Archeologia*

54 (1973), pp. 261–306. The Art Institute's casket was previously published in *Art Institute of Chicago Museum Studies* 30, 2 (2004), pp. 21–22.

4. On the phenomenon of Islamic works of art in medieval European church treasuries (including painted ivories from Norman Sicily), see Avinoam Shalem, *Islam Christianized: Islamic Portable Objects in the Medieval Church Treasuries of the Latin West*, Ars faciendi 7 (Frankfurt: Peter Lang, 1996), pp. 110–12, 129–41; and idem, "From Royal Caskets to Relic Containers: Two Ivory Caskets from Burgos and Madrid," *Muqarnas* 12 (1995), pp. 24–38.

### Ewer, pp. 73–74.

1. For more on the history and significance of the kendi form, including its early origins and uses, its status as a Chinese export, and its conversion into water pipes, see Joo Ee Khoo, *Kendi: Pouring Vessels in the University of Malaya Collection* (Oxford University Press, 1991).

2. For more on this practice and its functions, see Edward Wenham, "Silver-Mounted Porcelain," *Connoisseur* 97, 416 (Apr. 1936), pp. 189–94; W. W. Watts, "English Silver with Chinese Influence," *Antiques* 44, 5 (Nov. 1943), pp. 221–23; Yvonne Hackenbroch, "Chinese Porcelain in European Silver Mounts," *Connoisseur* 136 (June 1955), pp. 22–28; and Sir Francis Watson, *Mounted Oriental Porcelain*, exh. cat. (Washington, D.C.: International Exhibitions Foundation, 1986), in which the Art Institute's ewer is published as p. 40, cat. 6.

### Woman Before an Aquarium, pp. 74–75.

1. Henri Matisse, "Il faut regarder toute la vie avec les yeux d'enfants," *Le Courrier de l'U.N.E.S.C.O.* 6, 10 (Oct. 1953), based on an interview by Régine Pernoud. Translated as "Looking at Life with the Eyes of a Child," *Art News and Review* (Feb. 6, 1954), p. 3; retranslated in *Matisse on Art*, ed. Jack D. Flam, rev. ed. (University of California Press, 1995), pp. 217–18.

2. Pierre Schneider suggested that Matisse also may have visited the Paris Exposition Universelle in 1900, which featured Algerian, Moroccan, Persian, Tunisian, and Turkish pavilions; see Pierre Schneider, *Matisse*, trans. Michael Taylor and Bridget Strevens Romer (Rizzoli, 2002), p. 156. Schneider also noted that Islamic art was exhibited at the Musée du Louvre, Paris, in the early twentieth century.

3. Letter from Henri Matisse to Henri Manguin, n.d. [end of May/early June 1906], Archives Jean-Pierre Manguin, Avignon, as translated in Hilary Spurling, *The Unknown Matisse: A Life of Henri Matisse: The Early Years 1869–1908* (Alfred A. Knopf, 2000), p. 358, n. 74.

4. Ibid., p. 360.

5. Letter from Henri Matisse to Henri Manguin, Mar. 1, 1912, Archives Jean-Pierre Manguin, as translated in Pierre Schneider, "The Moroccan Hinge," in *Matisse in Morocco: The Paintings and Drawings, 1912–1913*, exh. cat. (Washington, D.C.: National Gallery of Art, 1990), p. 32, n. 95.

6. The textile in the background of this painting, known as a *haiti*, is an example of one of the many objects the artist collected during his travels. For more on this subject, see Ann Dumas, Jack Flam, and Remi Labrusse, *Matisse, His Art and His Textiles: The Fabric of Dreams*, exh. cat. (Royal Academy Books, 2004).

### Sled, pp. 75–76.

1. Peter Noever, "Between Two Worlds: An Act of Self-Assertion," in idem, ed., *Crimania: Icons, Monuments, Mazàfaka/Sergei Bugaev Afrika*, exh. cat. (Stuttgart: Cantz Verlag, 1995), p. 5.

2. As quoted in Hannah Andrassy, "Just Do It," www.thingsmagazine.net/text/t11/justdoit.htm.

### Triptych Icon with Central Image of the Virgin and Child, pp. 76–78.

1. C. Griffith Mann, "The Role of the Painted Icon in Ethiopian Culture," in *Ethiopian Art: The Walters Art Museum* (Walters Art Museum/Third Millenium Publishing, 2001), p. 121.

2. Béatrice Riottot El-Habib and Jacques Mercier, *L'Arche ethiopienne: Art chrétien d'Ethiope*, exh. cat. (Paris-Musées/Fundació Caixa de Girona, 2000), p. 145.

3. Ibid. See also Stanislaw Chojnacki in collaboration with Carolyn Gossage, *Ethiopian Icons: Catalogue of the Collection of the Institute of Ethiopian Studies, Addis Ababa University* (Skira, 2000), p. 36.

4. Chojnacki and Gossage (note 3), p. 33. See also "The Virgin of S. Maria Maggiore," in Stanislaw Chojnacki, *Major Themes in Ethiopian Painting: Indigenous Developments, the Influence of Foreign Models, and Their Adaptation from the 13th to the 19th Century*, Äthiopistische Forschungen 10 (Wiesbaden: F. Steiner, 1983), p. 217.

5. In rural Ethiopia, infants and young children wear cowrie shells as protective talismans; see Roderick Grierson, "Our Lady Mary with Her Beloved Son, Kwerata Reesu (Christ with a Crown of Thorns), and Saints," in *African Zion: The Sacred Art of Ethiopia*, ed. Marilyn Heldman and Stuart C. Munro-Hay, exh. cat. (Yale University Press, 1993), pp. 98–99, cat. 13.

6. The painting is believed to have arrived in Ethiopia in the sixteenth century; for a lengthy discussion of this work and the imagery it inspired, see Stanislaw Chojnacki, *The "Kwer'ata Re'esu: Its Iconography and Significance; An Essay in Cultural History of Ethiopia*, Annali dell' Istituto Universitario Orientale, suppl. 42 (Naples: Istituto Universitario Orientale, 1985). Based on the inclusion of the *Kwer'ata Re'esu* imagery, which is so clearly associated with the kings of Gonder, Marilyn Heldman believes this painting and several other related works were produced in or near the city of Gonder (personal communication, 2007, files, department of African and Amerindian Art). Jacques Mercier, in contrast, suggested that these works come from the region of Lasta; see El-Habib and Mercier (note 2), p. 145.

### Bhaishajyaguru Mandala, pp. 78–79.

1. Raoul Birnbaum, *The Healing Buddha* (Shambhala, 1979), pp. 16–17.

2. For an excellent exploration of the Buddha's many manifestations, see Jackie Menzies, ed., *Buddha: Radiant Awakening*, exh. cat. (Sydney: Art Gallery of New South Wales, 2002).

3. John F. Avedon et al., *The Buddha's Art of Healing: Tibetan Paintings Rediscovered*, exh. cat. (Rizzoli, 1994), p. 74.

4. Birnbaum (note 1), p. 83.

5. One of the most influential figures in this story of transmission is Xuanzang, the famous seventh-century Chinese monk who traveled through Central Asia into India and back in search of true Buddhist manuscripts. His popular translations of the *Bhaishajyaguru-Sutra* were fundamental in spreading the Medicine Buddha's cult.

6. These deities are often called *devas*, gods of the celestial realm. In the left row (top to bottom) are likely Vishnu, Indra, Agni, Yama, and Nairtya; in the right (also from top to bottom) are possible representations of Varuna, Vayu, Kuvera, Ishana, and Brahma. For a comparative example, see Marylin M. Rhie and Robert A. F. Thurman, *Worlds of Transformation: Tibetan Art of Wisdom and Compassion* (New York: Tibet House, 1999), pp. 416–17.

7. These figures, sometimes called the Four Heavenly Kings, are (from left to right) Virudhaka (south), Dhrtarashtha (east), Vaishravana (north), and Virupaksha (west). For a comparative example, see Marylin M. Rhie and Robert A. F. Thurman, *Wisdom and Compassion: the Sacred Art of Tibet*, rev. ed., exh. cat. (New York: Tibet House/Harry N. Abrams, 1991), pp. 336–37.

8. Pratapaditya Pal, *Himalayas: An Aesthetic Adventure*, exh. cat. (Art Institute of Chicago/University of California Press, 2003), p. 190.

### Griffin Protomes, pp. 80–81.

1. The date for these protomes was proposed by Michael Bennett of the Cleveland Museum of Art in a conversation with Mary Greuel, July 2006. The primary reference for Greek griffin protomes is Ulf Jantzen, *Griechische Greifenkessel* (Berlin: Gebr. Mann, 1955); for examples similar to the Art Institute's, see pp. 107–19, pls. 21–58.

2. The following account is based on the research of classical folklorist Adrienne Mayor, first published in abbreviated form in "Guardians of the Gold," *Archaeology* 47 (Nov./Dec. 1994), pp. 53–58; and later more fully in *The First*

*Fossil Hunters: Paleontology in Greek and Roman Times* (Princeton University Press, 2000), pp. 15–53.

## Bell *(Bo cheng)*, pp. 81–82.

1. The largest and most spectacular chime set to date was unearthed in 1978 from a tomb in Leigudun, Suizhou, Hubei Province. For the cultural and archaeological context of this site and the role of bells in ritual performance, see Lothar von Falkenhausen, *Suspended Music: The Chime-Bells of the Chinese Bronze Age* (University of California Press, 1993), esp. pp. 5–11, 25–31; John F. Major and Jenny F. So, "Music in Late Bronze Age China," in *Music in the Age of Confucius*, ed. Jenny F. So, exh. cat. (Freer Gallery of Art and Arthur M. Sackler Gallery/University of Washington Press, 2000), pp. 13–34; Robert Bagley, "Percussion," in ibid., pp. 35–64; and Lothar von Falkenhausen, "The Zeng Hou Yi Finds in the History of Chinese Music," in ibid., pp. 101–13.

2. The walls of each bell are almond shaped in cross-section and precisely tapered so as to emit two distinct tones, one by striking the central axis of the lower panel and a second by striking either side. See Lothar von Falkenhausen and Thomas D. Rossing, "Acoustical and Musical Studies on the Sackler Bells," in Jenny F. So, *Ancient Chinese Bronzes from the Arthur M. Sackler Collections*, vol. 3, *Eastern Zhou Ritual Bronzes from the Arthur M. Sackler Collections* (Arthur M. Sackler Gallery/Harry N. Abrams, 1995), pp. 447–49. Fang Jianjun of the Xi'an Conservatory of Music examined the Art Institute's bell in February 2004. He identified two distinct tones in this bell, as well as in each of three with corresponding designs: one larger example in the Freer-Sacker Gallery of Art, Washington D.C. (41.9) and two smaller ones in the Arthur M. Sackler Gallery, Harvard University (1943.52.179–80). These four bells are recognized to be components of a single set that was dispersed in the early twentieth century.

3. For schematic drawings of the surface decoration on this bell and those in the Freer-Sacker and at Harvard University (note 2), see George W. Weber, Jr., *The Ornaments of Late Chou Bronzes: A Method of Analysis* (Rutgers University Press, 1973), p. 253, fig. 118; p. 256, fig. 119; p. 258, fig. 120.

4. For identifications of these creatures as birds, see Charles Fabens Kelley and Ch'en Meng-chia, *Chinese Bronzes from the Buckingham Collection* (Art Institute of Chicago, 1946), p. 80; and Weber (note 3), pp. 254–55. They are described as winged dragons in Lothar von Falkenhausen, "Ritual Music in Bronze Age China: An Archaeological Perspective" (Ph.D. diss., Harvard University, 1988), pp. 504–05. Those on the Freer bell are described as "crested, parrot-beaked, wing-legged creatures" in *A Descriptive and Illustrated Catalogue of Chinese Bronzes Acquired During the Administration of John Ellerton Lodge*, Oriental Studies (Freer Gallery of Art) 3 (Smithsonian Institution, 1946), p. 64. In China, Late Bronze Age dragons generally share long, serpentine trunks but otherwise are remarkably diverse; some among these sprout horns, crests, and/or wings.

5. Jessica Rawson has convincingly isolated similar anatomical features within the complex surface patterns of many Eastern Zhou bronzes; see Rawson, *Chinese Jades from the Neolithic to the Qing* (British Museum Press, 1995), pp. 64–66; and idem, "Strange Beasts in Han and Post-Han Imagery," in *Nomads, Traders, and Holy Men Along China's Silk Road*, ed. Annette L. Juliano and Judith A. Lerner, Silk Road Studies 7 (Brepols, 2002), p. 24, fig. 2. The rhyton mentioned here is illustrated in a line drawing in "Houma tao fan yishu gailun" [The Houma Foundry Debris], in Shanxi sheng kaogu yanjiusuo [Institute of Archaeology of Shanxi Province], *Houma tao fan yishu gailun/Art of the Houma Foundry* (Princeton University Press, 1996), p. 16, 55, fig. 27:2; English summary by Robert Bagley, p. 87.

6. That the decoration of this bell was probably designed and executed by craftsmen in far northern China seems clear from excavations of the huge foundry site at Houma, Shanxi Province. There archaeologists retrieved fragments of clay models and molds for birdlike suspension devices and intricate surface patterns that incorporate layered and textured wings closely resembling those spread across the top of the Art Institute's bell. See *Houma tao fan yishu gailun* (note 5), p. 99, pl. 537; p. 134, pls. 79–81; p. 274, pls. 537–38.

## Teapot, pp. 85–86.

1. For examples from the 1876 Philadelphia Centennial, which introduced American audiences en masse to Moorish wares and designs, see Phillip T. Sandhurst, *Great Centennial Exhibition Critically Described and Illustrated* (Philadelphia: P. W. Ziegler, 1876), pp. 200–01, 225–33; Walter Smith, *Masterpieces of the Centennial International Exhibition Illustrated* (Philadelphia: Gebbie and Barrie, 1876–78), pp. 23–24, 188, 272; *Gems of the Centennial Exhibition* (New York: D. Appleton, 1877), pp. 41–43, 124–26; and Frank H. Norton, *A Facsimile of Frank Leslie's Illustrated Historical Register of the Centennial Exposition, 1876* (New York: Paddington Press, 1974), pp. 229–31, 275, 289, 302–04, 310–11. For the role of world's fairs in advancing Orientalism in the decorative arts, see Charles L. Venable, *Silver in America*, exh. cat. (Dallas Museum of Art/Harry N. Abrams, 1994), pp. 107–21.

2. Additional information on Moore's collection and designs, as well as a reproduction of the 1867 service, can be found in Elizabeth L. Kerr Fish, "Edward C. Moore and Tiffany Islamic-Style Silver, c. 1867–1889," *Studies in the Decorative Arts* 6, 2 (Spring/Summer 1999), p. 45.

3. Osborne's biography and contributions to both Whiting and Tiffany are detailed in Katharine John Snider, "'An Air of Originality and Great Richness': The Professional and Private Papers of Silver Designer Charles Osborne, 1871–1920," *Winterthur Portfolio* 36, 4 (Winter 2001), pp. 167–90.

4. For a reproduction of the other service (now in the Dallas Museum of Art) as well as a description of its potential uses, see Venable (note 1), pp. 128–30, 337, fig. 6.7.

## Leaf from a Qur'an, pp. 86–87.

1. Abdelkebir Khatibi and Mohammed Sijelmassi, *The Splendour of Islamic Calligraphy* (Thames and Hudson, 1994), pp. 96–97.

2. For more on the relationships between early calligraphic variations, see François Déroche, *The Abbasid Tradition: Qur'ans of the Eighth to the Tenth Centuries A.D.*, Nasser D. Khalili Collection of Islamic Art 1 (Nour Foundation/Azimuth Editions/Oxford University Press, 1992).

3. François Déroche, "Notes sur les fragments coraniques anciens de Katta Langar," *Cahiers d'Asie Central* 7 (1999), pp. 65–73.

## Talismanic Textile, pp. 87–88.

1. Merwyn Hiskett, *The Course of Islam in Africa* (Edinburgh University Press, 1994), p. 100; and Nehemia Levitzion, "Islam in Africa to 1800: Merchants, Chiefs, and Saints," in *The Oxford History of Islam* (Oxford University Press, 1999), p. 477.

2. For more on magic squares in West Africa, see Labelle Prussin, *Hatumere: Islamic Design in West Africa* (University of California Press, 1986). For their use and meaning among the Sufis of Senegal, see Allen F. Roberts and Mary Nooter Roberts, *A Saint in the City: Sufi Arts of Urban Senegal*, exh. cat. (UCLA Fowler Museum of Cultural History, 2003).

3. Roberts and Roberts (note 2), p. 21.

4. Ousmane Kane, "An Islamic Textile from Senegal," (lecture, Art Institute of Chicago, May 19, 2002); notes in object file, Department of African and Amerindian Art.

5. Prussin (note 2), p. 85, cited a 1502 account by a Portuguese, Valentim Fernandes, who described such devices worn by Moroccan holy men in Senegal; Prussin speculated that, by the late sixteenth century, they were widely used by chiefs throughout the region.

## Converging Territories #21, p. 89.

1. Lalla Assia Essaydi, *Converging Territories*, exh. cat. (New York: powerHouse Books, 2005), p. 28.

2. Ibid.